IMAGES
of America

NORTHWESTERN LEHIGH COUNTY

On the cover: This photography was taken around the 1930s on the Frank G. Metzger and Lena R. Metzger (née Walker) farm. Frank (May 11, 1881–May 17, 1966) and Lena (November 1, 1884–October 8, 1973), along with their seven children, worked the family farm. Frank (center) is standing between two of his daughters. On the left is Ella (March 13, 1909–December 2, 1996) who later married George "Benjie" Krause and on the right is Ruth (January 17, 1912–June 8, 2005) who married Ezra Lentz. The trio is standing in front of a truck load of potatoes, the lifeblood of the farmers. In the rear is a cinder-block garage built between 1927 and 1936 as the dates can be found in the cement floor and also painted on the wall. (Courtesy of Dennis and Sally Alexander.)

IMAGES
of America

NORTHWESTERN
LEHIGH COUNTY

The Weisenberg-Lowhill Historical Society
and the Lynn-Heidelberg Historical
Society Book Committee

ARCADIA
PUBLISHING

Published by Arcadia Publishing
Charleston SC, Chicago IL, Portsmouth NH, San Francisco CA

Printed in the United States of America

Library of Congress Catalog Card Number: 2006922347

For all general information contact Arcadia Publishing at:
Telephone 843-853-2070
Fax 843-853-0044
E-mail sales@arcadiapublishing.com
For customer service and orders:
Toll-Free 1-888-313-2665

Visit us on the Internet at http://www.arcadiapublishing.com

CONTENTS

ACKNOWLEDGMENTS

This book was created and written by the Weisenberg-Lowhill Historical Society and the Lynn-Heidelberg Historical Society Book Committee. The committee members are: Donald Campolongo, book coordinator; Donald Breininger, president of Weisenberg-Lowhill Historical Society; Carl Snyder, president of Lynn-Heidelberg Historical Society; Phyllis Breininger, Heidelberg representative; Donna Wolfe, Weisenberg representative; Carol Betz, Lowhill representative; and Irwin Hamm, Lynn representative.

The primary sources of photographs and documents in the book were the archives of the Lynn-Heidelberg Historical Society and the archives of Weisenberg-Lowhill Historical Society. Additional sources were the private photographic collections of Dennis and Sally Alexander, Laila Arndt, Lee and Colleen Behler, David and Karen Bivans, Mildred Bogert, Carl and Phyllis Breininger, Donald and Norma Breininger, Jim and Betsy Burnhauser, Donald and Ruth Campolongo, Virginia Snyder Christman, Fern Danner, Jeanette Delong, Lewis Donat, Carol Dorney, Barbara Dotterer, Gary Dotterer, Sally Drabick, Nelson Fogel, Sam Follweiler, Wayne and Ruth Frey, Verna Fritzinger, Paul and Charles Fritz, Ernest Geiger, Herbert Grim, Mearl Hahn, Irwin Hamm, Joyce Hamm, Willard Haas, Mary Henry, Lucille Heintzelman, Ray Holland, Harold and Elaine Hoppes, Mary Ellen Jones McDonald, Marie Snyder Kistler, Erna Kohler, Kermit Kressley, Dale and Eleanor Lakatosh, Forrest and Nancy Laudenslager, Lehigh County Historical Society, Earl and Gladys Leiby, Kermit and Roma Loch, Richard Metzger, Robert Miller, Daniel and Shoanna Pfeifly, Sterling Raber, Mary Redline, Ludwig and Arlene Rauscher, Terry and Linda Rehrig, Lillian Rupp, Tim Rupp, Rodney and Diane Schlauch, Carol Snyder Shirley, Annabelle Smith, Carl Snyder, Grace Hunsicker Snyder, Willard and Lucille Snyder, June Steiner, Mildred Weaver, Weisenberg Township, Mildred Werley, Donald Werley, Joyce Wink, Mike and Donna Wolfe, Hilda Yeager, Ralph and Pat Zettelmoyer, and Gloria Zimmerman.

INTRODUCTION

The northwestern region of Lehigh County is a rural area comprised of four townships; Heidelberg, Lynn, Lowhill, and Weisenberg. The area was first settled by the Pennsylvania Germans beginning in the 1730s. The region was on the frontier during the French and Indian War and a colonial fort, known as Fort Everett, was built for protection against the American Indians. Even with the fort, several American Indian massacres occurred in the region, including one in which all members of the George Zeisloff family was killed. After the French and Indian War, the area continued to grow as more Germans settled and cleared the land for farming. During the American Revolution, many of the settlers served in the Colonial militias and army.

Following independence from Great Britain and into the next century, the four townships grew as America expanded. Some statistics for the townships are as follows: 1845 Lynn, 10 gristmills, five sawmills, three churches, and a population of approximately 1,900; 1845 Lowhill, 10 gristmills, five sawmills, two clover mills, and a population of 854; 1845 Heidelberg, nine gristmills, seven sawmills, one furnace, two woolen mills, one gun manufacturer, several tanneries, up to 15 distilleries, and a population of approximately 2,300; 1884 Weisenberg, five gristmills, three sawmills, a tannery, four distilleries, six hotels, six stores, four post offices, a carriage factory, four churches, and 11 schools. While life in northwestern Lehigh County was primarily rural and agricultural, many small towns and villages were settled. In each, small town life and industry developed. Yet the backbone of the economy was still farming.

The inhabitants in the region were primarily Pennsylvania Germans who spoke a dialect of German we have come to call Pennsylvania Dutch. These Pennsylvania Germans were from the Palatinate Rhine Region of Germany and Switzerland and were mostly of the Lutheran or Reformed religious faiths. Many left their homeland during the Reformation and the 30 Years War in Europe when people were looking for religious freedom and prosperity.

With the coming of the 20th century, life slowly began to change for the region. A railroad was built, which allowed farm produce to be sent to market. Roads were paved and the horse and buggy began to give way to the automobile and truck. Life changed, but not as quickly as in some areas of the country.

This book contains photographs of the four townships and the residents living there from between 1870 and 1950. The book depicts a way of life that, in many ways, is gone and lost forever. Small-town America, local manufacturing, dirt roads, horses and motor cars, close-knit families, one-room schools, and family farms are all memories we want to preserve and record for posterity.

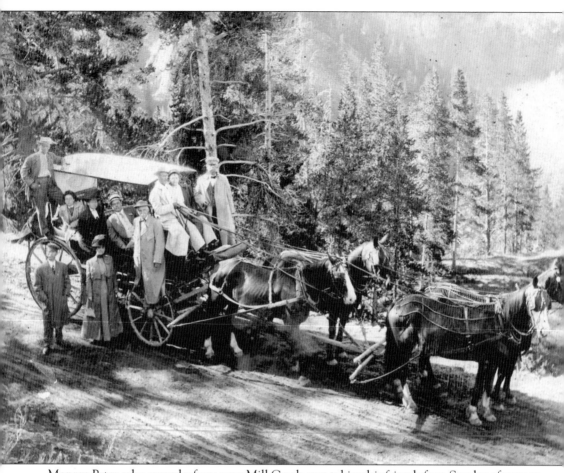

Monroe Peter, who owned a farm near Mill Creek, was taking his friends for a Sunday afternoon outing. They are in a four-horse-drawn carriage driving from their farm up over the Blue Mountain by way of Furnace Road.

One

HEIDELBERG TOWNSHIP

Prior to 1752, the area known as Heidelberg Township was called Heidelberg District and was part of Berks County. Heidelberg Township was established on June 16, 1752, and originally also included areas later known as Lynn and Washington Townships. Lynn Township was carved out of Heidelberg in October 1752, followed by Washington Township in May 1847. Thus, Heidelberg Township's area consisted of 26.3 square miles or 17,000 acres.

Trout Creek, Jordan Creek, and Crowner's Run all flow through the township. Numerous mills were constructed along these water sources but especially along the Jordan Creek. In 1845, the township included nine gristmills, seven sawmills, one furnace, one fulling mill, two woolen mills, a gun and rifle factory, tanneries, and 10 to 15 whiskey distilleries.

The township had only one church known as Heidelberg Church. The church was a union church of both Reformed and Lutheran faiths. The church is located one mile east of Saegersville near the center of the township. The church, schoolyard, and cemetery were built in a small valley. The first log church was erected prior to 1756. When it burned, a second log church was built on the site. A third church was constructed in 1849 on the other side of the creek from the original log buildings. It was renovated in 1882 and a soldiers' memorial monument was erected in the church cemetery in 1910.

The earliest schools in the township were log structures. The first school, dating back to 1756, was located at Heidelberg Church. The first English school was built in Saegersville in 1823 as a one-story log building and was used until 1880. In 1884, one-room brick school houses were built according to state requirements. The schools were Saegersville, Germansville, Pleasant Corner, Mantz's, Harter's, Peter's Church, Central, Water Pond, and Hawk. These one-room schools all ceased operations by 1951.

In 1874, the Schuylkill and Lehigh branch of the Reading Railroad built four miles of track through the township with one station at Germansville called Lehigh Exchange. The railroad connected Reading with Slatington.

There are numerous towns and villages in Heidelberg: Saegersville (located near the center of the township), Germansville, Deibertsville, Pleasant Corner (originally called Holbensville), Jordan Valley, and Germans Corner. Census records list population statistics as follows: 1,900 in 1820; 2,208 in 1830; 2,354 in 1840; and 3,279 in 2000.

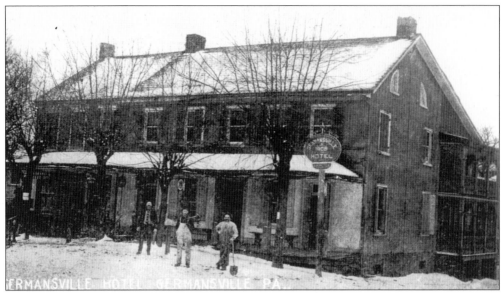

This is Germansville Hotel around 1900. The hotel was built around 1842 and was a center of social life in the area, housing a barber shop, general store, and post office. The hotel was used for parties, weddings, celebrations, a meeting place, and as an office for the tax collector. During the 1950s, George and Maggie Schlosser were the proprietors. In 1990, it was sold and converted into apartments.

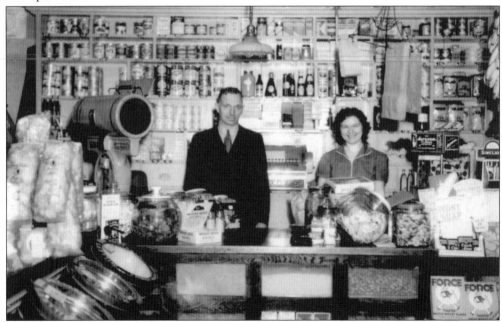

George Herber and his daughter Lillian are photographed in their Germansville country store. Most essential items could be purchased as the store carried food, clothing, shoes, boots, hardware, and all varieties of dry goods. Items in the store were a feast for the eyes. In one corner was a cabinet of sewing thread in various colors. Cookies came in big boxes and were sold by the pound. A large cabinet held a variety of penny candy and was a favorite of school children. The Germansville Post Office was also located in the store.

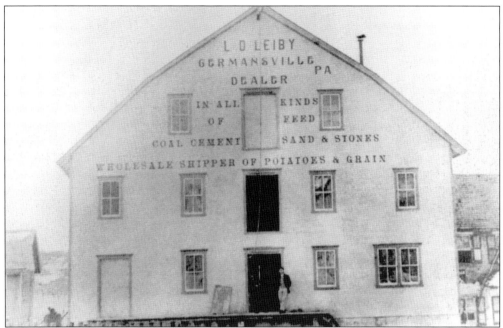

The first German's Mill was built by Adam German in 1742 on a land grant from William Penn. After Adam German's death, Philip German Sr. erected a two-story mill in 1814. A mill race was constructed in 1809. Subsequent owners were; Nathan German (1840), Philip Dieffenbach, Emos Dieffenbach (until his death in 1898), Howard K. Kern (until 1903), and William Grosscup. The mill was leased to Lewis D. Leiby and William J. Schmick for five years. Leiby bought the property and rebuilt a three-story structure. Later owners were Elmer and Mary Bittner, Mauser Mill Corporation (1935), Ralph O. Phillips (1944), Rodney and Diane Schlauch (1986), and it is currently known as Germansville Feed and Farm Supply.

Timbers used to build this garage were originally from the tannery in Saegersville. Dr. Elmer Behler owned the garage until it was taken over by his son, Wayne. Beginning in 1922, Wayne's son, Lee, operated the garage for several years. The Germansville Garage was known for having one of the first air car lifts in the area. This garage is located on Hunter's Hill Road in Heidelberg Township.

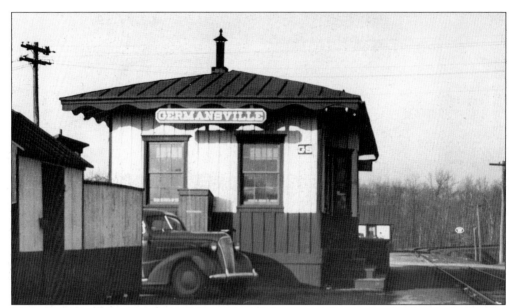

This is a 1930s view of the Schuylkill and Lehigh branch of the Reading Railroad, also known as the Berksy Line, in Germansville at the Lehigh Exchange.

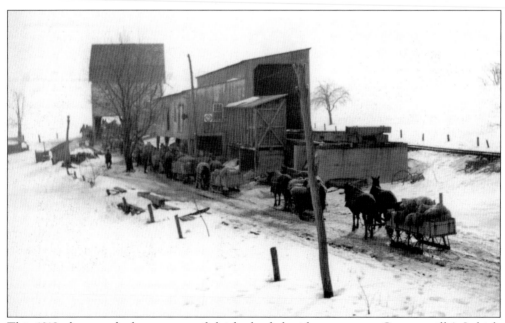

This 1918 photograph shows a row of sleighs loaded with potatoes at Germansville's Lehigh Exchange. The potatoes are to be loaded onto a train for delivery to market.

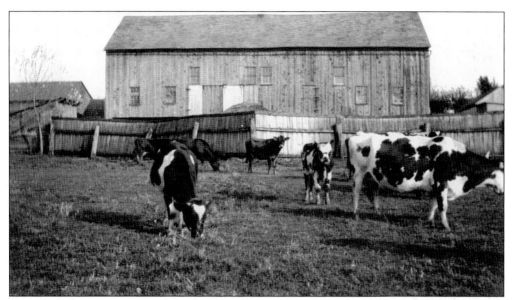

A herd of dairy cows grazing on the Eugene Handwerk farm in Germansville is captured on film in 1913. Many local farmers supplemented their farming income from crops by raising dairy cows. Cows had to be milked twice a day, every day of the year.

This is an early-1900s photograph of a horse and sleigh during a heavy snowstorm in Germansville. The view is looking towards the intersection of Bake Oven Road on Memorial Road.

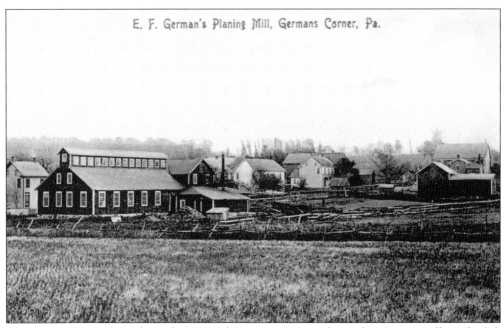

This postcard view from the early 1900s of Germans Corner shows the planing mill on the left side. Henry G. German started a store and planing mill in 1895, which he operated until his death in 1900. The mill was closed in 1910.

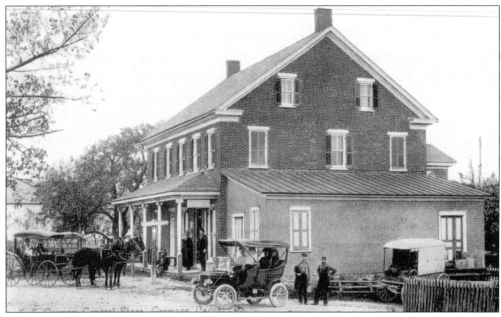

This is an early-1900s postcard view of Germans Corner store. The original store was started by Henry F. German who operated the store until his death in 1900. His nephew Edwin F. German succeeded as store owner.

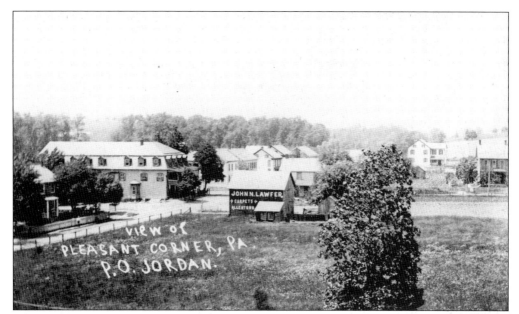

Here is a postcard view of the village of Pleasant Corner.

The Jordan Inn was built in 1928 by Victor and Mabel Rauch because their daughter wanted a hotdog stand. The Rauch's modeled their menu after the popular meals served at Shankweiler's Hotel in Fogelsville. The Jordan Inn was open for Sunday dinners, and the favorite meal was chicken and waffles. Customers paid $1.25 for an all-you-can-eat meal, which also included a dessert. The inn could be rented for banquets, parties, and other events. In 1948, Richard and Frances Fogel purchased the business. The dinner price was then raised to $2. The restaurant was sold in 1980 and the name changed to the Butternut Inn. The building burned in February 1997.

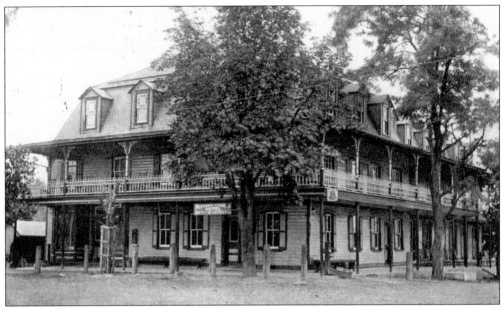

This is a view of the Pleasant Corner Hotel, one of the larger hotels in the area. The hotel had 40 rooms for summer boarders and also housed a general store and the Jordan Post Office, named after the nearby Jordan Creek. In more recent times it served as a circus museum, but was demolished, and a municipal building is on the site.

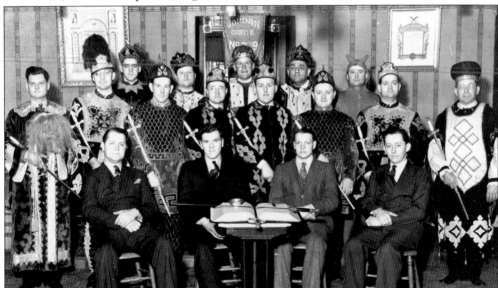

There were many lodges and clubs in the northwestern Lehigh County area. One of the more interesting was known as the Knights of the Golden Eagle Jordan Castle No. 379. Their meetings were held at the Pleasant Corner Hotel. In this 1939 photograph, third degree membership was conferred on new candidates. Members receiving the degree from left to right are (first row) Carl Loch, Bill Rauch, Milton Metzger, and William Stopp. Current members from left to right are (second row) Kermit Friebolin, Floyd Schmick, Ralph Longacre, Frank Krause, Russell Bittner, Kermit Schellhamer, Clarence Herber, and Oscar Sheirer; (third row) Marvin Harter, Warren Jones, Harvey Smith, Albert Bittner, and Paul Loch.

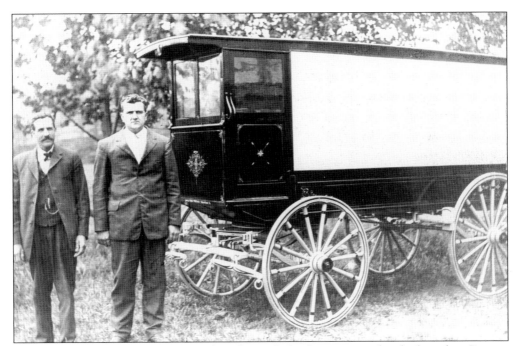

Seen here are Joseph and Victor Rauch in front of a huckster wagon they built at their Pioneer Carriage and Wagon Works.

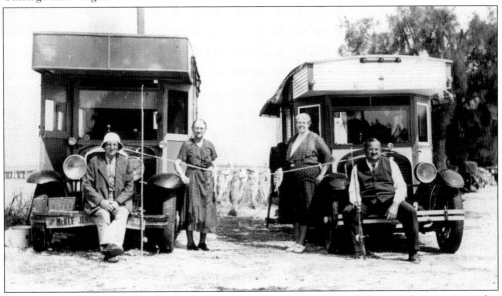

These were of the first locally built recreational vehicles. From left to right are Amandus and Melissa Handwerk, five freshly caught fish, and Mabel and Victor Rauch. Victor and his brother-in-law Amandus purchased the Pioneer Carriage and Wagon Works from Joseph Rauch, Victor's father. The young men built farm wagons, huckster wagons, and carriages at their Pleasant Corner factory, known as Rauch, Handwerk and Company. As the demand for automobiles increased, they expanded their business and started to market Buicks. The two families enjoyed traveling to Florida, and in an effort to save on hotel costs, Victor build two recreational vehicles on Buick chassis—one for each family.

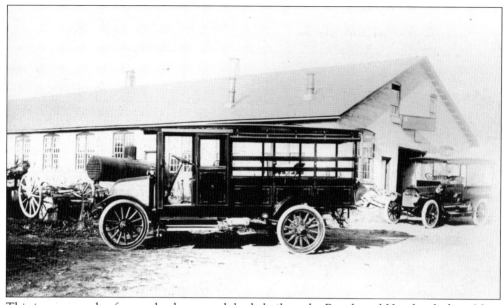

This is an example of a new huckster truck body built at the Rauch and Handwerk shop. Note the large steering wheel and solid rubber tires.

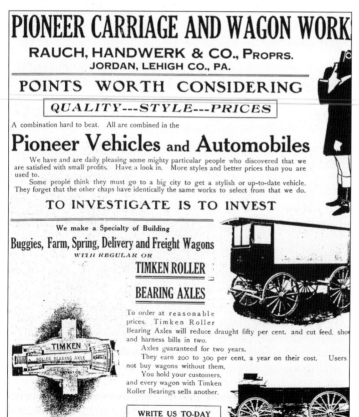

PIONEER CARRIAGE AND WAGON WORK

RAUCH, HANDWERK & CO., Proprs.
JORDAN, LEHIGH CO., PA.

POINTS WORTH CONSIDERING

QUALITY---STYLE---PRICES

A combination hard to beat. All are combined in the

Pioneer Vehicles and Automobiles

We have and are daily pleasing some mighty particular people who discovered that we are satisfied with small profits. Have a look in. More styles and better prices than you are used to.

Some people think they must go to a big city to get a stylish or up-to-date vehicle. They forget that the other chaps have identically the same works to select from that we do.

TO INVESTIGATE IS TO INVEST

We make a Specialty of Building

Buggies, Farm, Spring, Delivery and Freight Wagons
WITH REGULAR OR

TIMKEN ROLLER

BEARING AXLES

To order at reasonable prices. Timken Roller Bearing Axles will reduce draught fifty per cent. and cut feed, shoe and harness bills in two.

Axles guaranteed for two years.

They earn 200 to 300 per cent. a year on their cost. Users not buy wagons without them.

You hold your customers, and every wagon with Timken Roller Bearings sells another.

TIMKEN
ROLLER BEARING AXLE

WRITE US TO-DAY
FOR FACTS and FIGURES

This is an advertisement from the Pioneer Carriage and Wagon Works of Jordan, when it was owned by Victor Rauch and Amandus Handwerk. At this time Pioneer was still building wagons but had also begun selling automobiles.

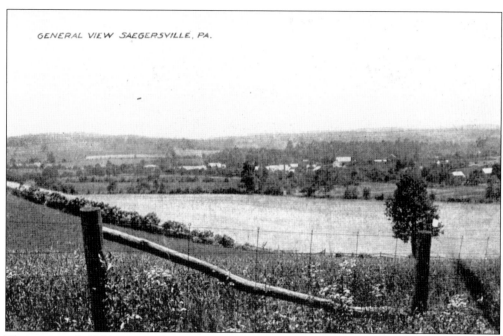

This is an early-1900s postcard showing a view of the Saegersville area.

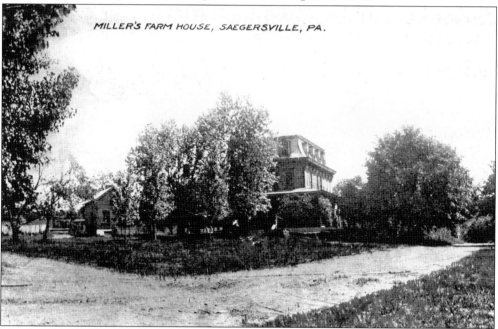

This large 15-room house is located in the village of Saegersville and was originally built as a three-story brick home with a wrap-around porch on two sides. The home contained a hand-dug basement, hand-hewn beams, side-plank floors, horsehair plaster walls, and an adjacent ground cellar. In 1947, a kitchen was added to the house. The original mansard roof was replaced with a slate gable roof because of a leakage problem. In 1865, Dr. Aaron Miller moved his large medical practice into this house using many rooms for patients. Subsequent owners included Sophia Miller, Charles B. Geiger and Roma Geiger (née Peter); and Robert B. and Reuben S. Geiger.

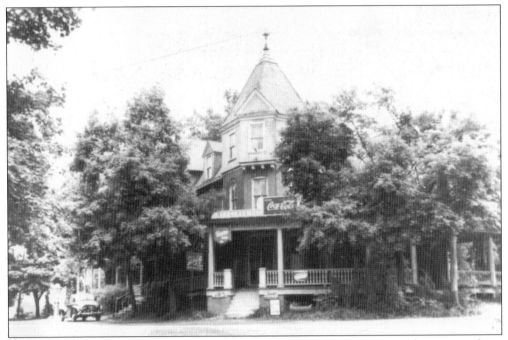

The Saegersville Hotel was a major landmark in Saegersville with 18 rooms for guests, a large kitchen, and two dining rooms where banquets and dinners were served. One of the local specialties on the menu was groundhog. The building contained a post office, established in 1829 with Joseph Saeger as the first postmaster. The hotel burned in October 1967.

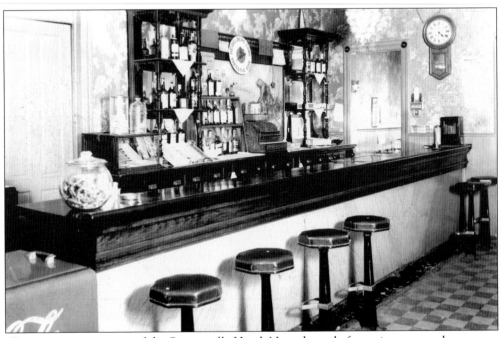

This is an interior image of the Saegersville Hotel. Note the soda-fountain-type stools.

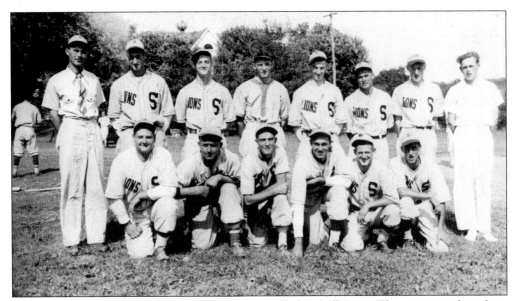

This is an early-1940s photograph of the Saegersville baseball team. The team members from left to right are (first row) Kermit Friebolin, Russell Kerschner, Albert Evans, Ivan Handwerk, David Handwerk, and Ralph Muthard; (second row) Elwood Handwerk (coach), Marvin Friebolin, Stewart Sell, Sterling Hunsicker, Leroy Kistler, Clair Mengel, Lloyd Kistler, and Charles Handwerk (coach). The team called themselves the Lions because both coaches went to Pennsylvania State College, whose mascot was the Nittany Lion.

This is a photograph of the Wehr and Peter family home taken prior to 1920. It is interesting to note that the brick walk in front of the house now extends under Route 309.

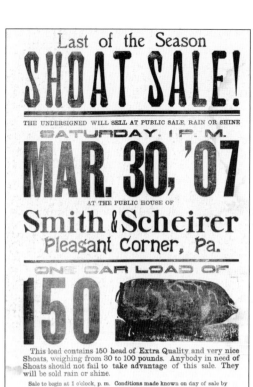

Last of the Season

SHOAT SALE!

THE UNDERSIGNED WILL SELL AT PUBLIC SALE, RAIN OR SHINE

SATURDAY. I P. M.

MAR. 30, '07

AT THE PUBLIC HOUSE OF

Smith & Scheirer

Pleasant Corner, Pa.

ONE CAR LOAD OF

150

This load contains 150 head of Extra Quality and very nice Shoats, weighing from 30 to 100 pounds. Anybody in need of Shoats should not fail to take advantage of this sale. They will be sold rain or shine.

Sale to begin at 1 o'clock, p. m. Conditions made known on day of sale by

GEO. A. BACHMAN

These are typical advertisements for local community activities. In an era before radio, television, mass entertainment, and the prevalence of cars, most of the population eagerly participated in local events. Occasions like ox roasts, auctions, barn raisings, parades, municipal band concerts, dances, and church gatherings provided the social life for farmers and townspeople in the northwestern Lehigh County region.

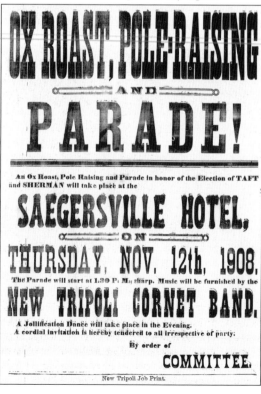

OX ROAST, POLE-RAISING

AND

PARADE!

An Ox Roast, Pole Raising and Parade in honor of the Election of TAFT and SHERMAN will take place at the

SAEGERSVILLE HOTEL,

ON

THURSDAY, NOV. 12th, 1908.

The Parade will start at 1.30 P. M., sharp. Music will be furnished by the

NEW TRIPOLI CORNET BAND.

A Jollification Dance will take place in the Evening.
A cordial invitation is hereby tendered to all irrespective of party.

By order of

COMMITTEE.

New Tripoli Job Print.

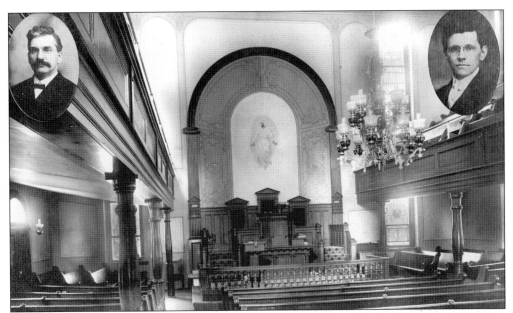

This interior view of Heidelberg Union Church in the 1920s shows the painting of the Ascension of Christ by artist Clinton Forward. An ornate gas-light chandelier can also be seen. The church was built with a second floor gallery, occupied by men and boys during the service. Women and girls sat downstairs.

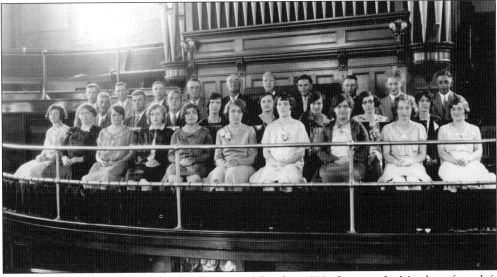

Members of the Heidelberg church choir posed for this 1930 photograph. Members from left to right are (first row) Arlene Hamm, Valero George, Mabel Handwerk, Arlene Christman, Verna Bittner, Edna Handwerk, Glendora Metzger, Stella Bachman, Beatrice Sittler, and Clara Delong; (second row) Henry Handwerk, Fred Handwerk, Warren Bittner, Ursula Bachman, Ida Fink, Roma Handwerk, Hattie Creitz, and Cena Fink; (third row) Elmer Leibensperger, S. Frank Creitz, Willis Hunsicker, Clarence Delong, Ulysses George, Ray Ruppert, Allen Handwerk, George Sittler, Stanley Hill, and Lawrence Bittner. The pewter communion ware in the glass enclosed display case is currently stored in a bank vault for safekeeping. The Reformed vessel is dated 1765 and the Lutheran is dated 1767.

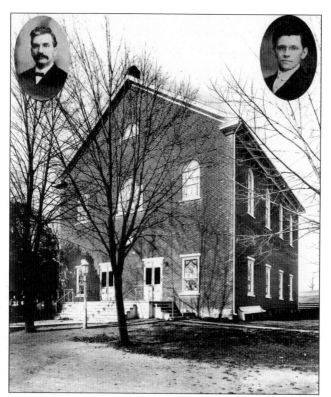

In 1740, the Heidelberg Union Church was organized and remained the only church in the township for more than 250 years. This union church consisted of two congregations, Lutheran and Reformed, who alternated Sunday services. It was customary for members to attend services every week regardless of their affiliation. The first three church buildings were built of logs, but in 1849 this brick church was constructed on the same site. This photograph was taken in the early 1920s when the Lutheran pastor (left insert) was Jacob H. Longacre (1901–1929) and the Reformed pastor (right insert) was Howard A. Althouse (1912–1924).

This 1857 confirmation certificate of Rosa Ann Lauchnor is typical of the ornate church and baptismal documents used in the area.

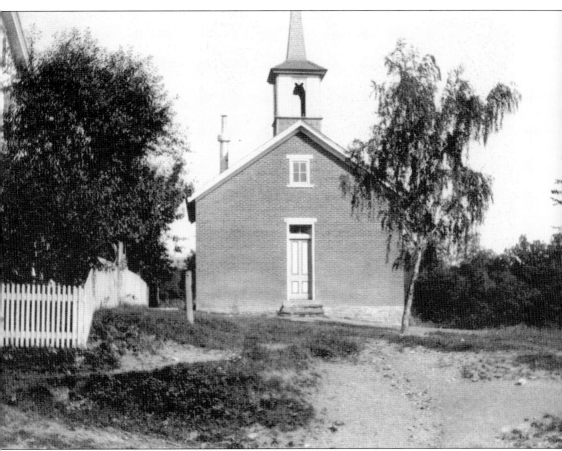

This *c.* 1900 photograph is of the Germansville one-room school. The school was built in 1887 at a cost of about $2,000. The brick came from the Neff's brick yard and the original potbelly stove was bought from tinsmiths William Adams and John Hail for $8. The building served as a school until it was closed in the mid-1950s, when all the one-room schools were closed. Many of the original fixtures and out buildings still remain, including the inside closets, slate board, coal shed, and one of the outhouses. The coal shed was turned into a shelter for goats who chewed on portions of the outside of the shed.

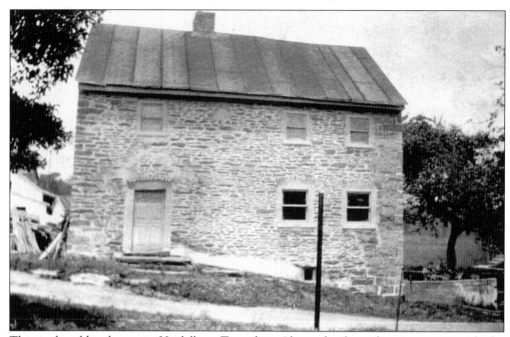

This is the oldest house in Heidelberg Township. Above the front door is a stone with the inscription *Hannes Handwerck mit Gott hab ich disz haus gebaut im jahr Christi anno 1769*, meaning "Johannes Handwerck with God's help I have built this house in the year of Christ A.D. 1769." The two-story stone building was orientated toward the points of the compass.

Germansville, Pa., _____ 194___

M_____

ELWOOD E. HANDWERK

POTATOES
"Is Our Business"
ALSO
**Massey-Harris Farm Equipment,
Combining, Pick-Up Baling
and Potato Spraying**
Telephone: Slatington 154-R-5

"If our work or product pleases you tell others, if not, please tell us.",

Elwood E. Handwerk was born, raised, and farmed on the Handwerk homestead in Heidelberg. The land was originally acquired by his ancestor Johannes Handwerck in 1769. In the 1940s, after attending Pennsylvania State College, Elwood Handwerk started a business to help neighboring farmers harvest and sell their crops. This is a copy of Handwerk's sales receipt with his motto Potatoes Is Our Business.

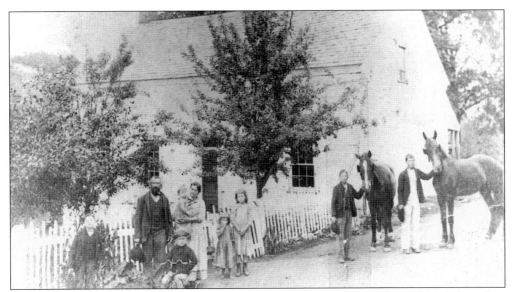

William German (standing second from left) and Sabilla German (née Donat) (standing third from left) were married on May 16, 1869. Along with seven of their 12 children, they are standing in front of their Jordan Valley farmhouse. Sabilla's marriage dowry consisted of six chairs, one stove, one chest, one sink, two bedsteads with bedding, four hogs, and a one-horse wagon. William, a Civil War veteran, served as a private in Company H, 209th Regiment of the Pennsylvania Volunteer Infantry from September 3, 1864, until his discharge in Alexandria, Virginia, on May 31, 1865.

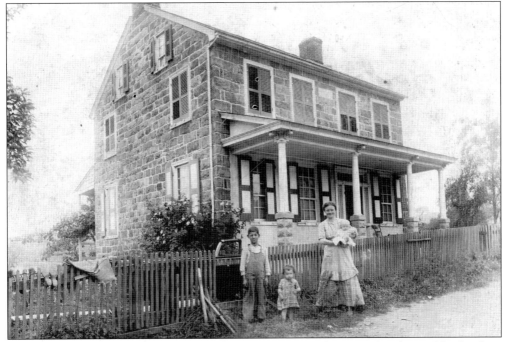

In 1914, Lillie Metzger holds her infant son Russell in front of her stone farmhouse. Her daughter Glendora (age 2) and an unknown boy are by the picket fence. Lillie and her husband Alfred farmed 80 acres.

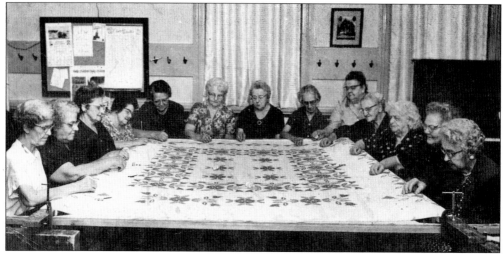

Rev. T. Bachman and Rev. G. Klick suggested the Heidelberg Union Church Ladies Aide Society officially organize in 1948. The group quilted once a week as a fund raiser. Prices charged were 65¢ per 100 yards of thread and 35¢ to hem the edges of quilts. In 1962, they reported having quilted 221 spreads, 11 comforters, and 1,483 aprons. Money earned was used to buy necessities for the church such as kitchen supplies, a refrigerator, and an electric range. Earnings were also donated to the Lutheran Home in Topton, Phoebe Home in Allentown, and needy families in the area. The members looked forward to these weekly gatherings as an important part of their social life. Seated around the table from left to right are Cena Kuntz, Florence Metzger, Arlene Strauss, Viola Fink, Mabel Hausaman, Lillie Metzger, Minnie Harter, Mamie Leibensperger, Lillian Hill, Della Hensinger, Annie Bachman, Verna Hamm, and Ida Hollenbach.

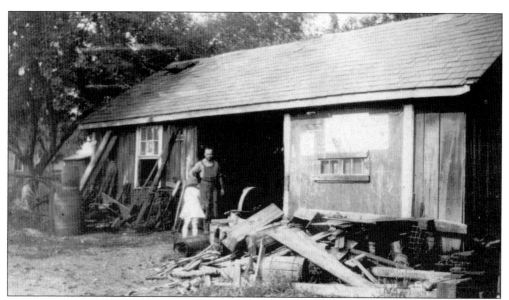

Clinton Fritzinger is standing in front of his blacksmith shop around 1900. He opened the business to help local farmers take care of their horses. When Fritzinger no longer operated the business it was not taken over by anyone else.

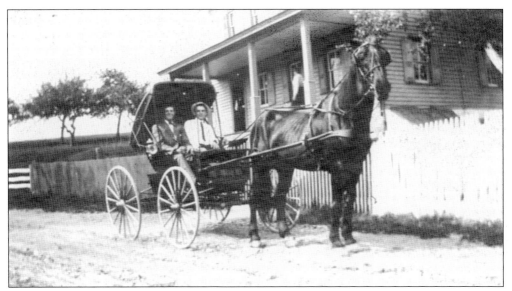

This photograph was taken in the early 1890s on Jordan Valley Road at the home and farm of the Friebolin family. It is believed the men in the buggy are Ralph and Howard Friebolin.

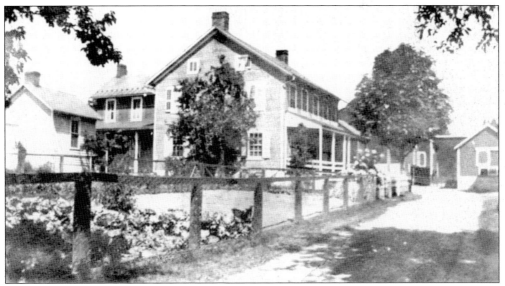

Here is the well-kept house and out buildings that were in the Sauerwine family for many years. Owners have included Owen Fink and Annie Fink (née Friebolin), James Sauerwine and Mabel Sauerwine (née Fink), Earl J Sauerwine, and Marvin Smale.

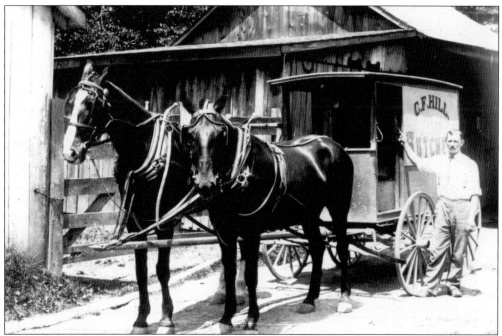

This 1900 photograph shows Calvin F. Hill with his butcher wagon. As a young man, Calvin built a butcher shop and icehouse on his father-in-law Menno Geiger's farm, near Newside. From this wagon Calvin sold beef, pork, sausage, and scrapple to people in the Newside, Neffs, and Schnecksville areas.

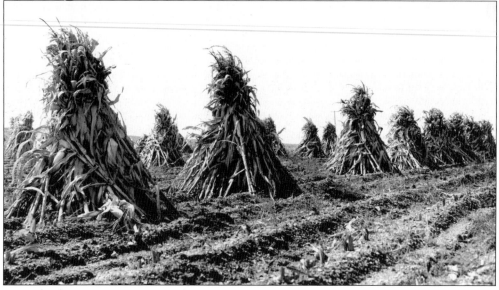

Corn shocks were a common sight on farms before mechanical huskers and shellers were invented. Corn stalks were cut off and tied together with several other corn stalks or tar string, thus forming the shocks and allowing the stalks to dry. This process was started around Labor Day. Later in fall, the corn was husked and thrown onto piles in the fields. The cobs of corn were gathered in bushel baskets, loaded onto a wagon, and brought to the farm for storage in corn cribs. The corn stalks were used as food for dairy cows.

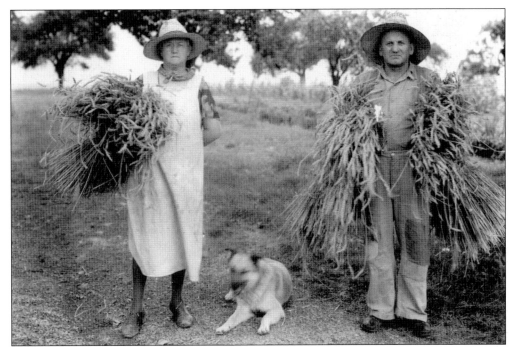

Frank Metzger and Lena Metzger (née Walter) stand with their dog Toots in this 1930s photograph. Frank was born May 11, 1881, and died May 17, 1966. Lena was born November 1, 1884, and died October 8, 1973.

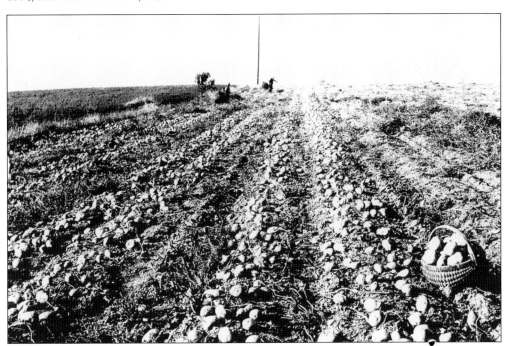

This photograph shows a freshly dug potato field on the Frank and Lena Metzger farm. Potatoes were dug by machine, but picking was done by hand with the pickers, usually family members, going down the rows and picking potatoes into oak baskets. Picking potatoes was a back-breaking task.

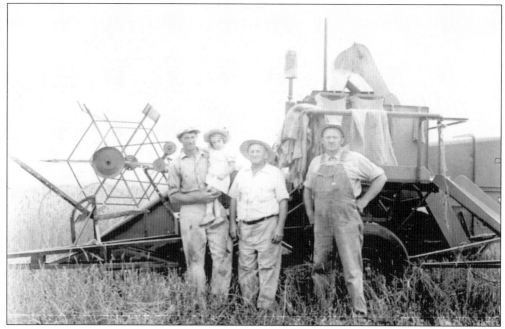

This photograph was taken around 1950 in a grain field on Frank and Lena Metzger's farm. The farm implement in the background was a Case combine. From left to right are George "Benjie" Krause, Sallyann Alexander (née Krause), Frank G. Metzger, and Charles Metzger.

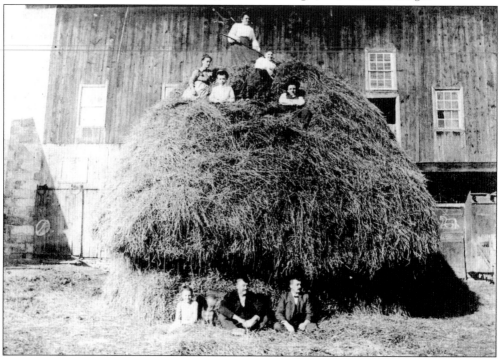

On Sunday afternoon, the Delong family visitors are frolicking in a fresh straw stack in front of the family barn. Note the indent around the base of the pile marking where animals had eaten into the base of the straw stack.

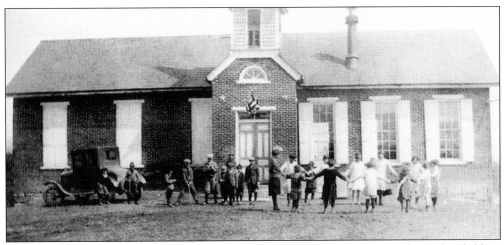

This mid-1920s photograph of Kemmerer's School in Heidelberg Township shows the children and teacher outside for recess. Floyd Frey started teaching at Kemmerer's School in 1924. Frey graduated from Kutztown State Normal School in 1923 and initially taught in Albany Township, but after marrying Edna Kerschner, moved to Kemmerer's School. Floyd's father-in-law Erwin Kerschner thought teaching was not profitable and convinced Floyd he could earn more than $600 a year as a farmer. Consequently, Floyd left the teaching profession.

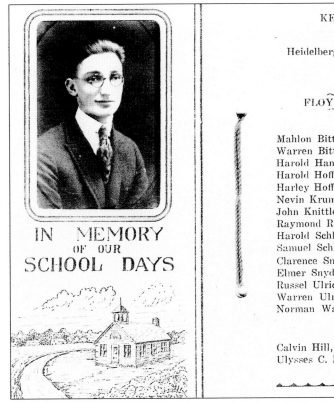

KEMMERER'S SCHOOL

District No. 9

Heidelberg Township, Lehigh County, Pennsylvania

1923-1924

FLOYD H. SCHMICK, Teacher

PUPILS

Mahlon Bittner	Erma Blose
Warren Bittner	Mildred Blose
Harold Handwerk	Berdelle Dorward
Harold Hoffner	Helen Handwerk
Harley Hoffner	Erma Kline
Nevin Krum	Ruth Kline
John Knittle	Viola Knittle
Raymond Rex	Luella LeVan
Harold Schleicher	Helen Rex
Samuel Schleicher	Florence Roberts
Clarence Snyder	Rachel Roberts
Elmer Snyder	Grandelene Roth
Russel Ulrich	Irene Schleicher
Warren Ulrich	Alverta Schleicher
Norman Walter	Minnie Ulrich

Arlene Walter

SCHOOL BOARD

Calvin Hill, Pres. Jacob Roberts, Treas.
Ulysses C. Mantz, Sec'y. Alvin Peters
Henry F. Smith

IN MEMORY OF OUR SCHOOL DAYS

This memento of school days at Kemmerer's School 1923–1924 was prepared and given to each student in the school. It shows a picture of the teacher, Floyd Schmick, and lists all the students as well as the school board.

Mary Alice Snyder was the daughter of Elias Snyder and Abigail Snyder (née Hunsicker). Mary was married to Frederick Metzger who died suddenly on January 1, 1904, at the age of 25. Frederick and Mary had three young sons. Upon Frederick's death, William, the oldest son, went to live with his grandparents. Dewey was raised by his uncle, Al Snyder. Lawrence moved with his mother to Allentown where she went to seek employment as a young widow. Mary later married Andrew Petri.

This is a c. 1900 photograph of Frederick and Mary Alice Metzger's children. The children from left to right are William, Dewey, and Lawrence Metzger.

Elias Snyder is proudly photographed in 1905 with his grandson Dewey Metzger at the Jordan Valley Hotel, now known as Bake Oven Inn. The Snyder family were the proprietors of the hotel along Bake Oven Road.

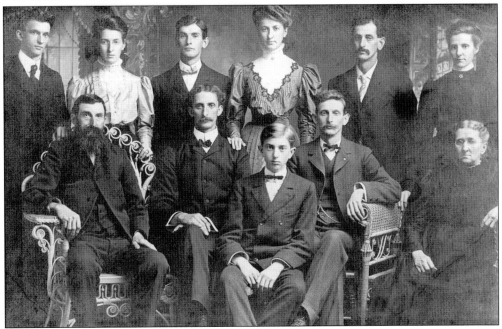

Family portraits were very popular heirlooms in the late 19th and early 20th centuries. In an era when not everybody had a camera, the entire family, dressed in their Sunday clothing, would go to a professional portrait studio. This c. 1900 photograph is an excellent example. Family members from left to right are (first row) Owen Krause, Charles Krause, Henry Krause, Edwin Krause, and Ellen Krause; (second row) Russell Krause, Mabel Snyder (née Krause), Fred Krause, Dora Loy, George "Pappy" Krause, and Ada Mantz.

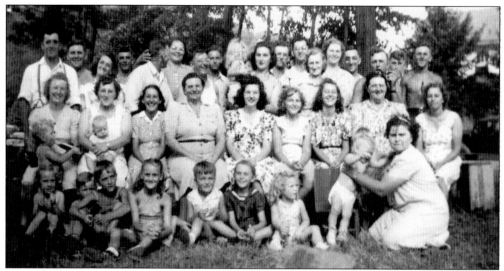

The Christman Family Picnic at their Pleasant Corner home in 1944. From left to right are (first row) Dolores Christman, Larry Dotterer, Harlan Wanamaker, Berdine Wanamaker, Donald Breininger, Marilyn Hausman, Doris Christman, Sandra Christman, and Beatrice Christman; (second row) Miriam and David Christman, Marguerite holding Carl Breininger, Lorraine Wanamaker, Bessie Werley, Jean Kressley, Shirley Christman, Joyce Hausman, Edna Christman, and Lillian Dotterer; (third row) George Christman, Royden Dotterer, Mabel Wanamaker, Kermit Christman, Calvin Christman, Edna Christman, Clarence Christman, Melvin Christman, Edith Christman holding Judith, Paul Hausman, Arlene Hausman, Arlene Christman, Ralph Christman, Frank Christman, Reuben Christman, and Thomas Christman.

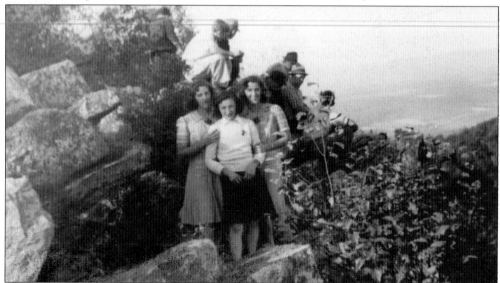

Along the Appalachian Trail and the dividing line between Lehigh and Carbon Counties is a collection of rocks known as Bake Oven Knob. It is a favorite place for visitors because of the indescribable view and is an observation point to view Allentown, Reading, and the Delaware Water Gap. At present, it is a favorite place for bird and hawk watchers. The three women in the front, from left to right, are Gladys Leiby (née Metzger), Arlene Lewis (née Moyer), and Grace Krumenacher (née Metzger).

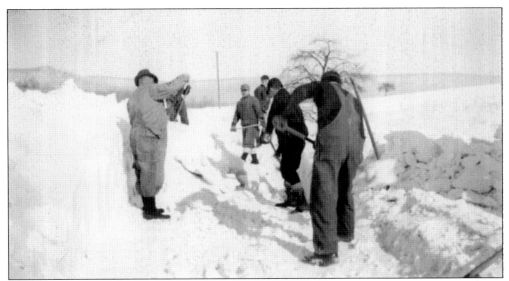

When snow plows could not move the deep snow drifts from township and state roads, crews of local farmers in the area lent a hand. Although they were paid an hourly wage, such neighborly tasks were a common occurrence. This photograph was taken between Jordan Valley Hotel and Haaks School House in the 1940s.

The forerunner of the above-ground swimming pool, parents Paul and Marguerite Breininger provided summer enjoyment for their sons (left to right) Carl, Kenneth, and Donald in their yard at their Pleasant Corner home. The pools are graduated in size and the tea kettle on the porch is handy to add warm water as needed.

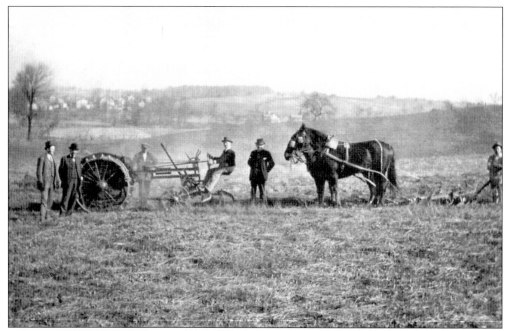

This is a *c.* 1900 demonstration of farming techniques. Horses and a hand guided plow were shown in comparison to the first tractor in Heidelberg Township.

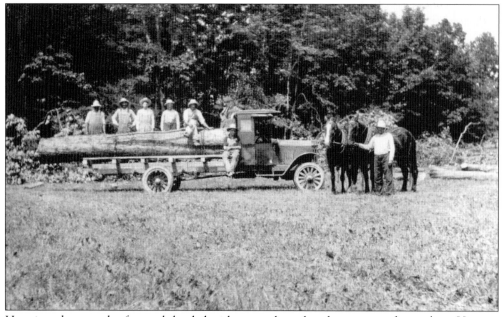

Here is a photograph of a truck loaded with a very large log that was cut down along Hunters Hill Road.

Two

LOWHILL TOWNSHIP

Lowhill Township is located in the central portion of Lehigh County. The Court of Quarter Sessions of Northampton County established the township on December 18, 1753. The township is approximately 9,000 acres, four and a half miles long, and three miles wide. Peter Derr, who petitioned the court to establish the township, was appointed the first constable of the district on September 16, 1755.

The Jordon Creek along with its tributaries Lyon Creek, Sweitzer Creek, and Mill Creek provided a valuable supply of flowing water winding through the township. Many mills were constructed along these creeks, but in 1760 Michael Mosser built the first mill in the township along Mill Creek near what is today the Trexler-Lehigh County Game Preserve.

Two churches were established, Lowhill and Morganland. Lowhill Church was built in 1769. Morganland Church, near Leather Corner Post, was built in 1858.

The Pennsylvania Germans valued education to enable their children to read the Bible. Education was basic and consisted of reading, spelling, writing, and arithmetic. Schools were located in seven districts, Lyon Valley, Highland, Morganland, Scheirers, Claussville, Lowhill Church, and Water Pond (operated jointly with Heidelberg Township). These one-room schoolhouses closed in 1956.

Several small villages grew within the township. Ruhetown was a cluster of small dwellings where several farmers retired. The German word for rest was pronounced "ruhe." These dwellings no longer exist and the area is part of the Trexler-Lehigh Game Preserve. Another village, Bittner's Corner was settled on land owned by Andreas Bittner. The village of Weidasville took its name from founder Peter Weida, who bought 200 acres of land in 1811. Lyon Valley is a village located on Lyon Creek, a branch of the Jordan Creek. Finally, the villages of Claussville and Leather Corner Post grew around taverns around 1800.

The township of Lowhill had enterprising businesses such as a carriage factory near Claussville operated by Levi Werley for nearly 50 years, a large trade in weaving at the home of Nathan Frey near Lowhill Church, and a machine shop near Lyon Valley started by the Kressley brothers. Woolen coverlets were made by the Seibert family.

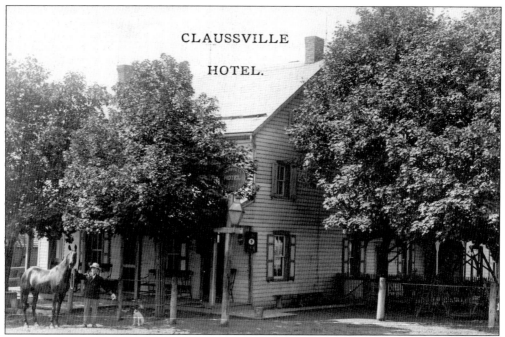

A two-and-a-half-story log structure covered with clapboard siding, the Claussville Hotel was built as a tavern in 1800 by David Schumaker. The logs can still be seen today. A post office was established on the premises in 1830 and John Schifferstein was appointed postmaster. Daniel Clauss was postmaster between 1834 and 1851. The village was named after Clauss.

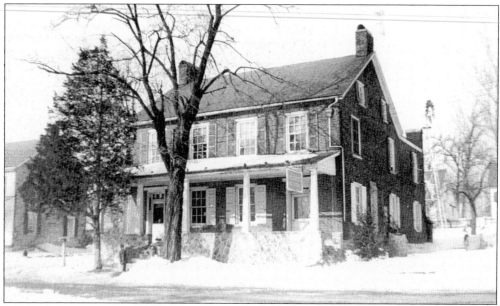

In 1844, Levi Knerr built a brick house and general store in the village of Claussville. The general store located in the tavern across the street was then closed. Richard Knerr succeeded his father in operating the business. Later William and Verna Dotterer renovated and enlarged the building where they owned and operated Dotterer's Modern Country Store until its closing.

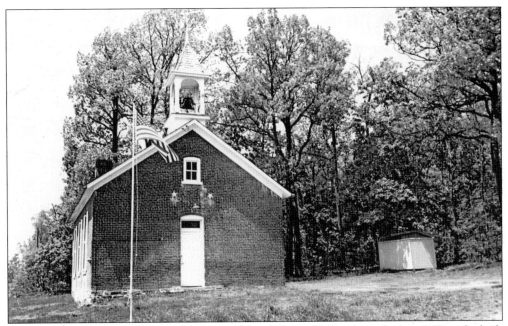

The first Claussville school, located at Route 100 and Kernsville Road, was built in 1867 and rebuilt in 1893 as the present brick structure. The school continued in operation until 1956 and all eight grades were taught by one teacher. The school is owned by the Lehigh Valley Historical Society.

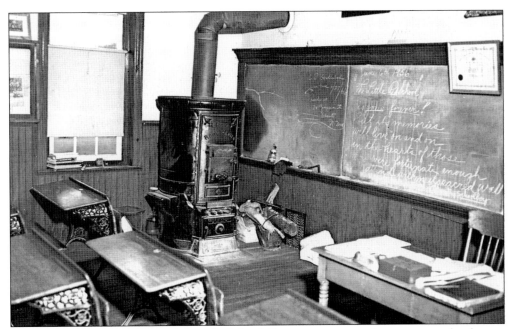

This is an interior view of the Claussville School. During winter months one-room schools were heated by a pot-belly stove. Older students were responsible for bringing in the wood and taking out the ashes.

The Lyon Valley General Store, on the right, is at the site of an early tavern and store founded by Daniel Bittner in 1845. Bittner's brother-in-law Jacob Zimmerman was appointed as the first postmaster in 1857; and in later years, a post office was located in the small building on the left. The tavern was abandoned by Jonas Fenstermaker in 1885, but the general store remained. Robert G. Kemmerer was storekeeper from 1910 until its closing in 1950.

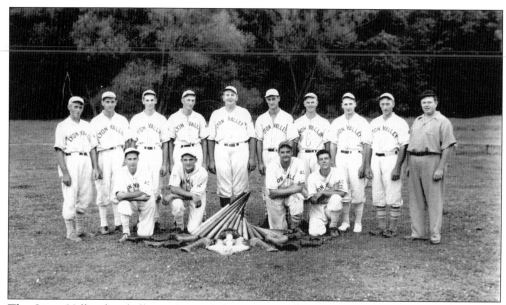

The Lyon Valley baseball team posed for this photograph in the summer of 1940. Team members from left to right are (first row) Sterling Werley, George Peters, Kermit Friebolin, and Harold Bachman; (second row) Clayton Dengler, Clifford Miller, Paul Sell, Ralph Bittner, Sterling Zimmerman, Marvin Friebolin, Ernest Fries, Raymond Kressley, Leo Kressley, and Paul Breininger. The team, providing local entertainment, played in various farmers fields in the Lyon Valley area before established a playing filed in the sheep pasture of General Harry Trexler's sheep ranch.

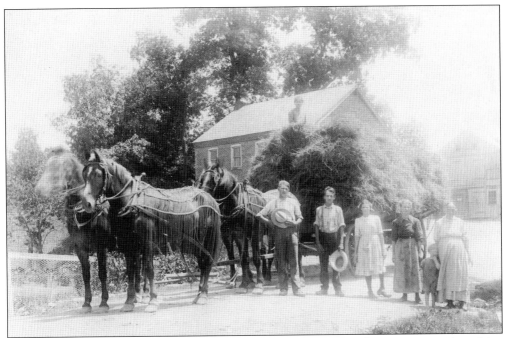

In 1854, three brothers, Jonathan, Joseph, and Jacob Kressley, opened a water-powered machine shop where they built and repaired farm implements. Their father, Jacob, had a shoe repair shop on the second floor. The three sons also had a blacksmith shop, which can be seen in the back right. The Kressley farm has been in the same family for over 150 years with seven generations working the farm. From left to right are Wilmer Kressley, Arthur Kressley, Bessie Haas, Mabel Kressley, Paul Breininger, Catherine Dengler, and Ellie Kressley on the hay wagon.

Mrs. Lilly and her granddaughters were photographed in front of the Lyon Valley Hotel when visiting the Lakatosh family. The hotel was built in 1852 and the date on the rafters is visible to this day. The mill to the right, built prior to 1800 by Jacob Fenstermaker, was operated by water power from the Lyon Creek.

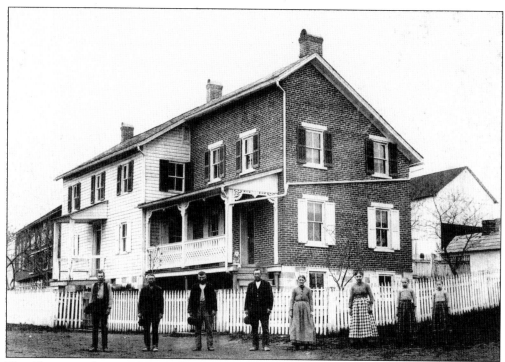

The Hensinger farm in Lyon Valley straddled the Weisenberg/Lowhill Township line where Elias gathered his family for this *c.* 1890 photograph. From left to right are Peter, John, Oscar, Elias, Eliza Hensinger (née Bittner) wife of Elias, Mantana Hensinger (née Weiss) wife of Oscar, Martha, and Emma. Elias Hensinger was the proprietor of the Lyon Valley General Store, succeeded by his son Peter.

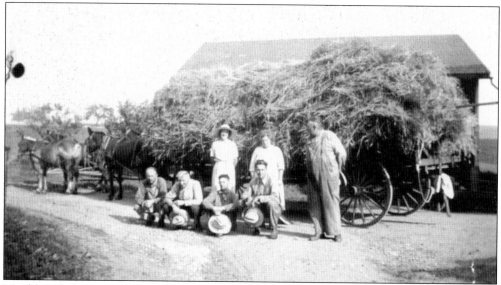

Neighbors helping neighbors was very important at harvest time. Lyon Valley haying has the Warren Miller family assisting the Oscar Hensinger family in bringing the hay to the barn. From left to right are (first row) Warren and Oscar Hensinger, and Clifford and Warren Miller; (second row) Ella Miller, Pauline Hensinger, and Francis Hensinger.

A carpet factory was located on the main floor of the center building in the foreground of this photograph. This is a view of the Edgar Greenawald farm along Carpet Street, Weisenberg Township. Several generations of the Greenawald family operated the large loom to supply rag carpets for the neighboring families.

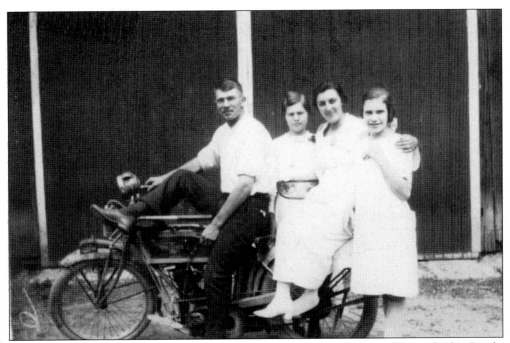

Charles Smith enjoyed many rides on his motorcycle. In this photograph are Charles Smith, Lillie Bittner (née Smith), and friends.

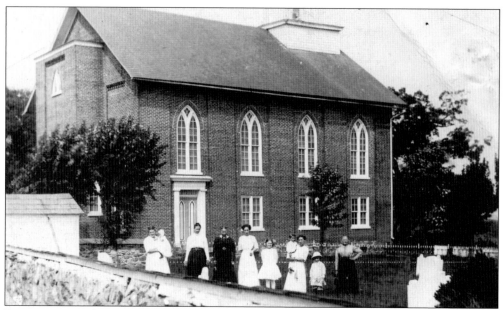

Due to a misunderstanding in the Weisenberg Church, some of the Lowhill people decided to build another church, within sight of the Weisenberg Church. On January 27, 1769, they organized a congregation and erected a church of their own. While the first log church was being built, services were held under a large oak tree. The church was dedicated on September 3, 1769. In May 1798, realizing their church was too small, the cornerstone was laid for another log church. Finally, a third church was built in 1858 on the same site. This current church was constructed of brick and still houses an active congregation.

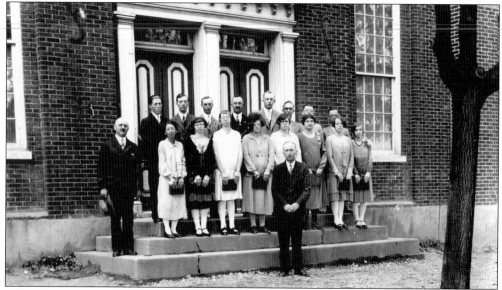

This photograph of the Lowhill Union Church choir was taken in 1929. From left to right are (first row) Warren Hensinger (church organist); (second row) Reverend Wenner, Celinda Hartman, Pearl Gruber, Dorothy Shoemaker, Hannah Kocher, Viola Snyder, Emma Gehringer, Loretta Rex, and Miriam Hartman; (third row) Harvey Kocher, Clayton Seibert, Arthur Seibert, Morris Bittner, George Snyder, Elvin Bittner, Walter Zettelmoyer, and Elmer George.

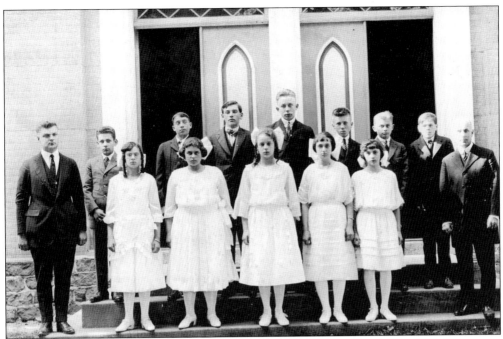

Seminarian Clarence Rahn conducted his first catechetical class of Lowhill in 1922. The young people were confirmed on October 29, 1922, by Reverend Braumer. In the photograph from left to right are (first row) Rev. Clarence Rahn, Mary Schoenly (née Bachman), Helen Wotring (née Millhouse), Loretta Rex (née Snyder), Esther Herber (née Schellhammer), Helen Kern (née Schuler), and Reverend Braumer; (second row) Robert J. George, Blaine Bachman, Claude Frey, George P. Snyder, Harvey Kocher, Paul Loch, and Elmer Frey.

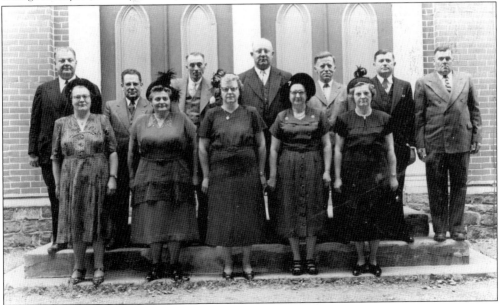

This photograph is a 25-year reunion of the 1922 confirmation class at Lowhill Church. Everyone is present and standing in the same position as the photograph above except for Claude Frey and Reverend Braumer who are not present in this photograph.

The Lowhill Reformed Church built the township's first school in 1786. Churches established most early Lehigh County schools in order to teach children religion, reading, writing, and arithmetic. This was the township's only school until 1855. The school day ran seven hours for the four winter months only. Students often missed school if they were needed to help at home on the farm.

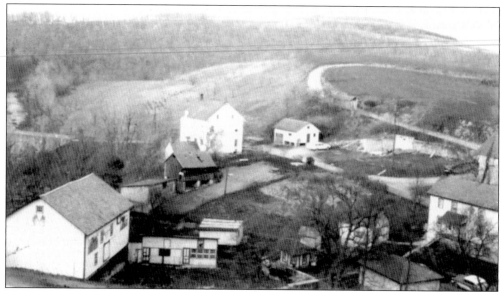

This view of Bittners Corner includes the farmstead of Charles Smith in the foreground with the beautifully decorated barn and unusual farm buildings. The home of the Frank Beck family is centered in the scene with only a portion of the barn seen behind the Smith house on the right. The road circling up the hill leads to the Bittner Mill property while the stone arched bridge on the left leads over Jordan Creek. Bittners Corner was named after the Andreas Bittner family who were responsible for establishing a hotel, general store, and several mills. A gristmill, sawmill, and clover mill were established before 1800 but abandoned around 1890.

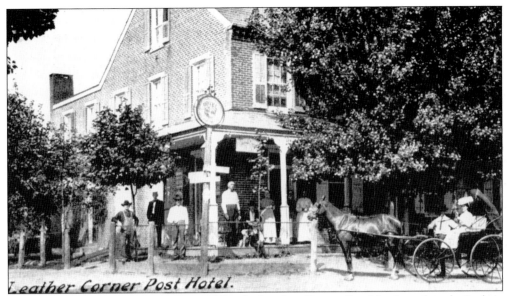

Leather Corner Post Hotel.

Built before the Revolutionary War in 1776, the Leather Corner Post Hotel was kept by Ludwig Smith and was used for many purposes. One story of how the hotel got its name was the result of a robbery of a nearby tannery. A valuable piece of leather was missing. The tannery owner was at the tavern and made mention of the theft. The hotel owner said, "Everything, will be all right in the morning." The next day the leather was found nailed to a hitching post in front of the tavern. Seen here from left to right are Charles Peters, unidentified, Richard Haas, Walter Miller, unidentified, unidentified, Annie Haas, Elton Faust, and Ella Handwerk.

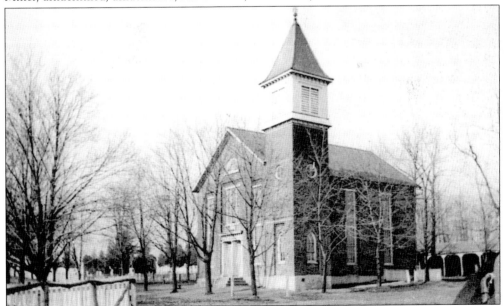

Morganland Union Church, situated near Leather Corner Post in Lowhill Township, was organized after a meeting on April 4, 1857. Morganland means "the land of the morning" in German. The church faces east into the morning sun, thus the name Morganland. The cornerstone of the first church was laid on August 23, 1857, and a year later on August 31, 1858, dedication services were held.

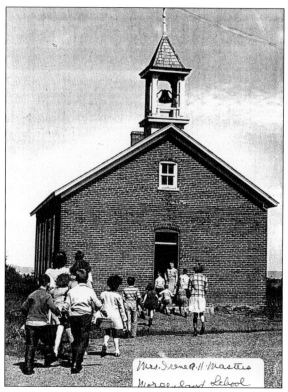

Early settlers in Lowhill Township valued an education as a means of enabling their children to read the Bible. Morganland School, also known as George's schoolhouse, was built around 1855. The school's education remained focused on reading, spelling, and arithmetic until it closed in 1956.

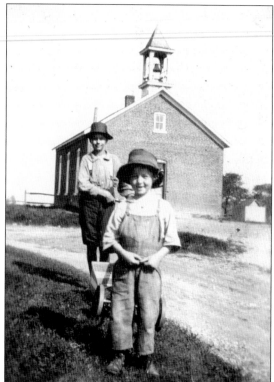

Ernest Geiger (back) and Carl Haas (front) lived next to the Morganland schoolhouse. Occasionally during bad weather, the school teacher stayed overnight at their home.

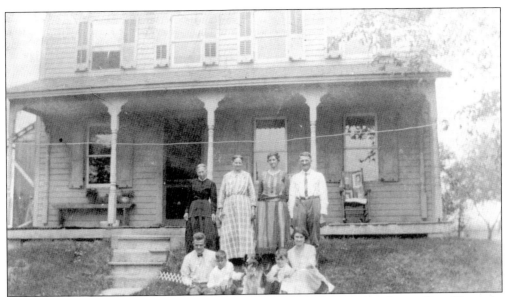

One of the oldest homesteads in Lowhill Township is located at Leather Corner Post. Shown in the family photograph from left to right are (first row) Clarence Haas, Ernest Geiger, Carl Haas, and Ceula Haas; (second row) Polly Diehl, Anna D. K. Haas, Flossie Geiger, and Richard Haas.

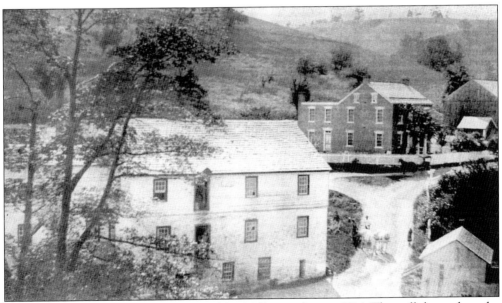

This view of the Mosser-Hollenbach-Stahley Mill was taken in 1914. The mill, located on the east side of Mill Creek in Lowhill, was built in 1800. Its original owners were Michael, Philip, Abraham, and Tobias Mosser as listed in the 1812 tax rolls. This mill replaced an earlier mill built by the Mosser and Fry family (first gristmill in the township) on the west side of the creek dating back to 1767. The mill had a long succession of owner/operators after Michael Mosser including John Hollenbach 1845–1858, Moses Hollenbach 1858–1901, Thomas B. Hollenbach 1901–1914, Rayam Stahley 1914–1947, and Herman A. J. Heep 1947–1953. In 1953, Herman turned the building into a private residence.

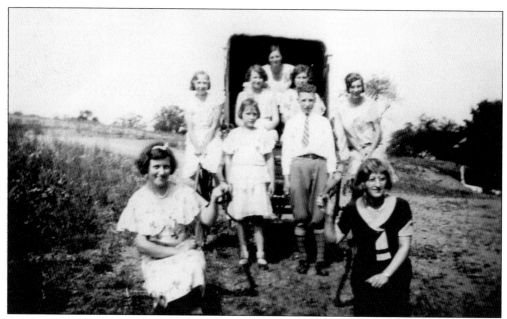

Sunday afternoon visitations were a time for fun, fellowship, and entertainment for teenagers and young adults. This photograph was taken around 1934 near the Kressley machine shop. From left to right are (first row) Luella Snyder and Marguerite Breininger; (second row) Evelyn Kressley and Raymond Kressley; (third row) Arlene Baush, Perma Werley, Arlene Kressley, and Jenny Seibert; (fourth row) Bessie Haas.

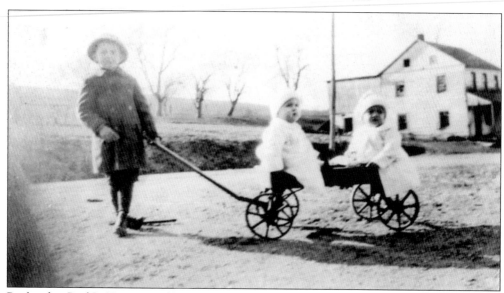

Big brother Paul L. Hausman of Lyon Valley is full of pride as he stands with his wagon carrying his twin sisters, Mamie (who later married Robert Breininger) and Cora (who later married Nelson Litzenberger). They are dressed warmly for this beautiful early spring day in 1919. The old farmhouse and barn in the background were razed soon after this photograph was taken.

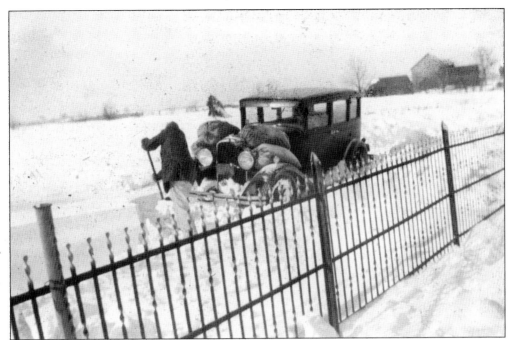

Ernest Geiger was on his way to the mill with bags of grain piled on the front fenders of his car. Even with this extra weight Ernest only managed to get a short distance from home. Ernest was stuck in deep snow at Francis Roth's house and had to resort to using a shovel.

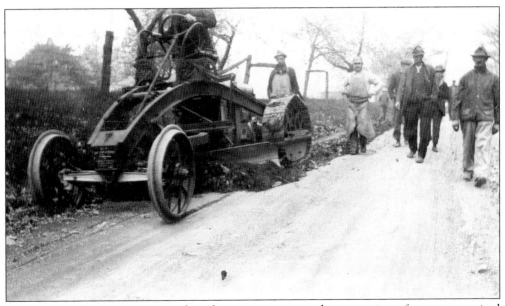

Lowhill Township supervisors and work crew are given a demonstration of a new motorized grader. This demonstration was on the road from Claussville to Route 100. In the photograph from left to right are an unidentified grader driver, an unidentified supervisor, supervisor Ed Trexler, an unidentified supervisor in dark trousers, Ernest Geiger (slightly behind supervisor), and Richard Haas (far right).

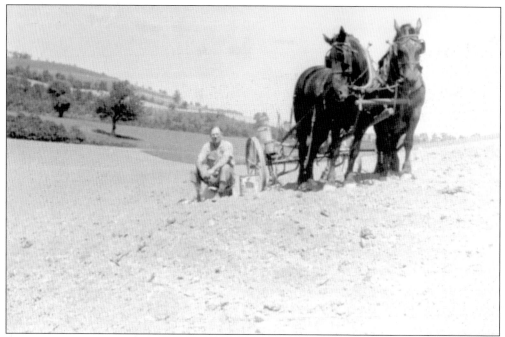

Charles Smith is planting a field of corn with his team of horses at one of his farms. Smith owned farms in both Lowhill and Weisenberg Townships.

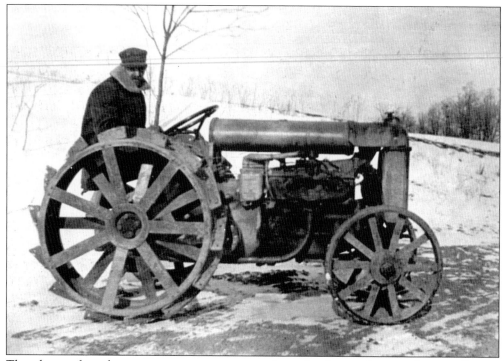

The change from horsepower to tractor was a dynamic change for area farmers. Francis Zettlemoyer operated this Fordson tractor on his farm near Bittners Corner. The steel wheels with rear cleats predated rubber tires.

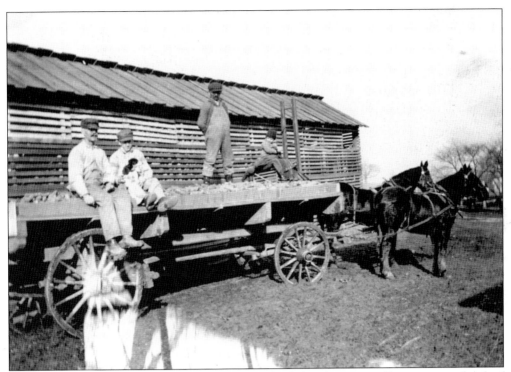

Assaba Greenawald and his family are on a wagon loaded with potatoes. Potatoes were the chief crop of many local farmers. In the background is a huge corncrib, which was located in Lowhill Township while the farmhouse was in Weisenberg Township.

Farming was a part of life for many Lowhill residents. Standing in front of his Oliver tractor is Adam Geiger with his grandchildren Barbara and Sterling.

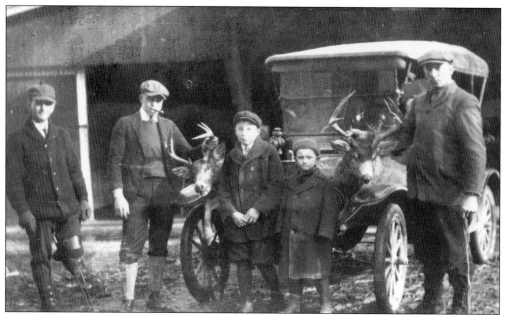

Lowhill residents traveled to Pike County in the early 1900s to hunt. The trip took six hours to reach their cabin at Potter Lake. The dirt road into the cabin was often so muddy they had to collect stones and put them under the wheels in order to continue driving. Standing from left to right are Henry Hunsicker (with an artificial leg), Mr. Mosser, Mr. Mosser's son, Howard Raber, and Eli Raber. Two large bucks are on the hood of the car.

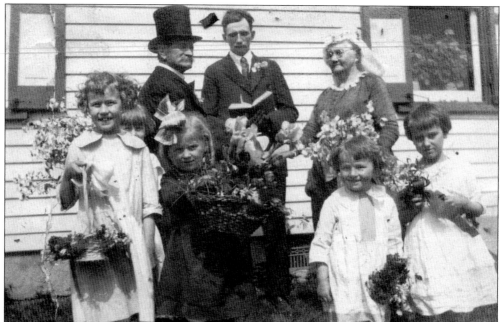

Wallace and Millen Geiger renewed their wedding vows with Robert Wortring officiating. Completing the wedding group as flower girls were their granddaughters. From left to right are Lillian Rupp (née Geiger), Frances Roth (behind), Lila Wieand (née Hausman), Verna Werley (née Geiger), and Beatrice Worman.

Three

LYNN TOWNSHIP

The Township of Heidelberg was established on June 16, 1752, and Lynn was subdivided out in October of the same year. Prior to 1752, Lynn, Heidelberg, and Albany Townships were known as the "Back Parts of Macungie." The area was also referred to as the Allemaengel meaning "all want," for it was a region that was destitute. It was in constant need of help. It lacked fertile soil, there were no roads, and there was no defense against the American Indians. The areas were considered part of Bucks County. In 1752, Albany became part of Berks County and Lynn and Heidelberg became part of Northampton County. In 1812, Lehigh County was carved out of Northampton County.

Originally Lynn Township was wilderness occupied by the Lenni-Lenape, a sub-tribe of the Delawares. The original inhabitants were a peaceful people until the Walking Purchase of 1737 in which William Penn and his sons took more land from the American Indians than had originally been agreed upon. This agreement caused distrust of the settlers and helped ignite massacres along this frontier during the French and Indian War (1756–1758) when the American Indians sided with the French.

Most of the early settlers in Lynn were of German and Swiss descent who continued speaking their native German language. These settlers served in the American Revolution, the Continental Army, and local militias. Frederick Leaser, a farmer living near Wanamakers, played a role during the war by helping to move the Liberty Bell from Philadelphia to Allentown for safe keeping when the British were about to overrun Philadelphia.

After America received its independence, and into the next century, Lynn Township continued to grow as large areas were cleared for farms. Lynn, although primarily a farming area, also contained villages, including New Tripoli (originally called Linntown and later called Saegersville), Mossersville, Lynnville, Jacksonville, Steinsville, Wanamakers, Stines Corner, Lynnport, Slateville, Oswaldsville, and Reitz's. The inhabitants of Linntown changed the name of their town to New Tripoli after the United States Marines invaded Tripoli on the coast of North Africa. In 1874, the Berks and Lehigh Railroad was built, which tied many of these small towns together and served as an easy route for commerce.

Several churches were built including Ebenezer Church organized in 1761, Jerusalem (Red) Church organized in 1743, Jacob's Church organized in 1750, St. Peter's Lynnville built in 1857, and a Moravian church built between 1751 and 1767. In 1914, there were 16 one- and two-room schools; Jacksonville, Fetherolf's, Steinsville, Slateville, Fenstermacher's, Lynnville, Kistler's Valley, Rausch's, Camp's, Rabert's Corner, Snyder's, Greenawald's, Weaver's, New Tripoli, Lynnport, and Bausch's (shared with Weisenberg).

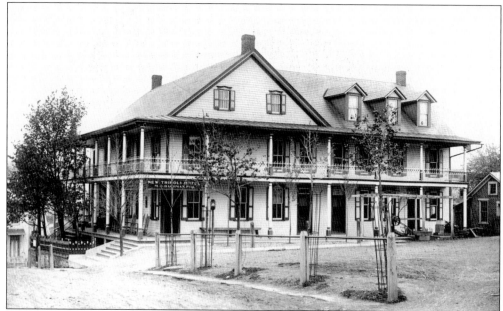

The New Tripoli Hotel was built in 1887 by William Krause. In 1905, it was purchased by Menno O. Bachman. The New Tripoli store, owned by James W. Loy, was also located in this building. Rails and posts used for tying horses and a kerosene post lantern along the sidewalk can be seen in the photograph.

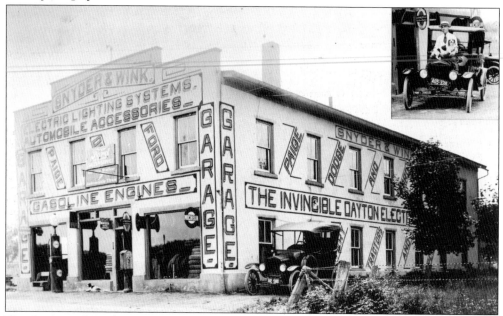

The Snyder and Wink Garage was built in 1914. From the advertisements the proprietor, Homer H. Snyder and his partner and half brother John Wink, sold a bit of everything including electrical lighting systems, automotive accessories, and gasoline engines. They also sold Ford, Dodge, and Paige vehicles; Dayton Electrical Motors; and gasoline. This was the first garage in New Tripoli and a prominent building for many years until it was destroyed by fire in the 1990s. In the top right corner is the owner Homer H. Snyder driving a Ford Model T with his dog.

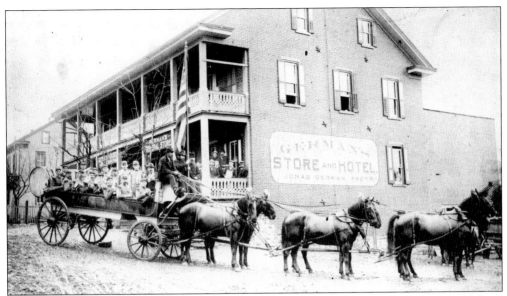

This early-1900 photograph of the New Tripoli Band was taken between the New Tripoli Hotel (later named Blue Ridge Inn) and German's Store and Hotel. The six-horse hitch and wagon were owned and driven by Nathan H. Snyder. Willoughby H. Snyder, Nathan's brother, is seated holding the flag. Behind the driver is Menno O. Bachman, band director. Nathan's wagon was used to transport the band to engagements and parades. A list of band members in 1910 is as follows: James D. Snyder, Charles Oswald, Albert Hermany, Francis P. Snyder, Herman Wuchter, Llewelyn Wertman, Worden A. Fritzinger, John Glase, Charles Grim, Richard Lentz, James A. Weaver, John S. Mosser, George H. Rabert, Fred Grim, John Wink, Henry E. Snyder, Edwin D. Snyder, Elias K. Gildner, George A. Krause, Charles Kuntz, Fred A. Bachman, Adolph G. Keiser, and Willoughby H. Snyder.

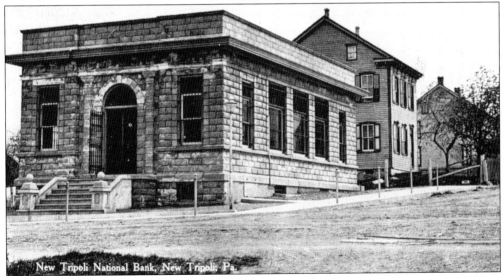

Construction on the bank started in 1909 and opening day was March 1, 1910. The bank building today is basically the same (inside and outside) with the exception of a peaked roof, which replaced the original leaky flat roof. The bank was built with iron bars on the windows and iron hitching posts along the street, which were used to tie horses while customers conducted business in the bank.

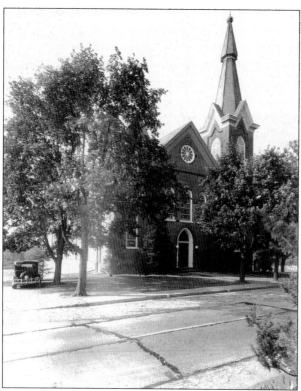

In 1740, the German settlers started meeting in a log house for religious services. In 1761, they built a simple log church with a dirt floor. This church, containing only an alter and an organ, became known as *Die Orgel Kirche* "Organ Church" or Linntown Church. The second church, built in 1798, was a two-story log structure. The third church, built in 1824, was constructed of stone at a cost of $2,400. The present church, shown here, was built in 1890 of stone and brick at a cost of $20,732.

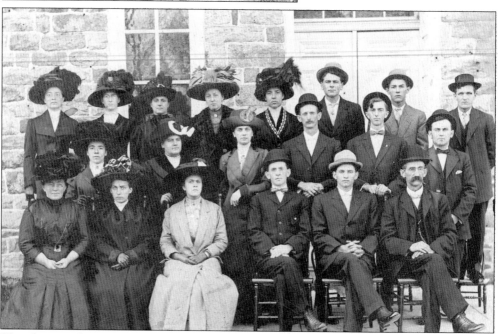

This photograph was taken at the side door of the Ebenezer Union Church, New Tripoli, in 1912. Looking their best in their finest Sunday clothing and hats, this is believed to be a gathering of the church choir. Only Mabel Snyder (née Krause) second from the left in the third row, and Charles German third from right in the third row have been identified.

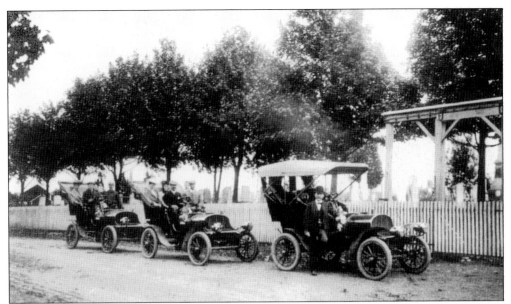

The Greenall family and friends from Allentown, on a Sunday drive into the country, are parked in front of Ebenezer Union Church Cemetery at New Tripoli. A Sunday outing could be a major event considering roads from Allentown to New Tripoli were all dirt and automobiles were prone to flat tires and mechanical problems.

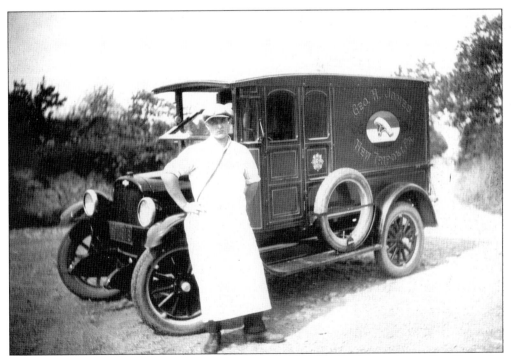

Warren Jones, son of George H. Jones, in a 1930s photograph, is standing in front of his Chevrolet butcher market truck. The butcher shop burned in 1942, and the site is the present location of the Northwestern Medical Center.

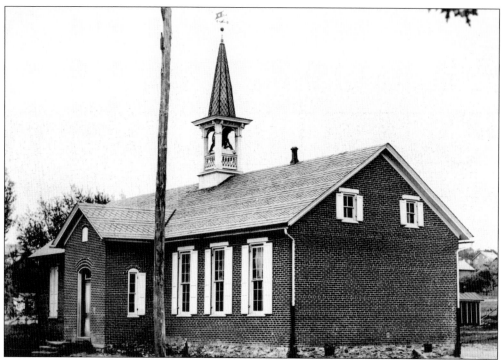

This photograph of the New Tripoli two-room elementary school was taken shortly after it was constructed in 1890. A white granite date stone in the gable peak at the front entrance lists school directors at the time as W. H. Reitz, S. J. Sittler, L. E. Klingaman, W. K. Krauss, G. S. Greenawald, and J. N. Hunsicker—contractor M. D. Wuchter. The school was built to comply with state specifications for a one-room school, which was simply doubled for a two-room school. Each room was designated for 50 pupils.

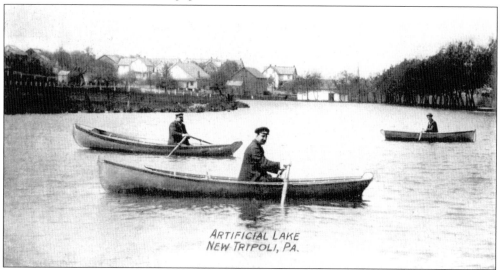

ARTIFICIAL LAKE
NEW TRIPOLI, PA.

The artificial lake in New Tripoli was a reservoir for the Saeger Gristmill. The mill was still in operation in the 1930s. In winter, the lake was used as a source of ice to stock icehouses in the surrounding area. The lake was also used for boating, swimming, and fishing. In the nearest boat is William Miller, owner of Miller's Hotel and Store (father of Richard K. Miller).

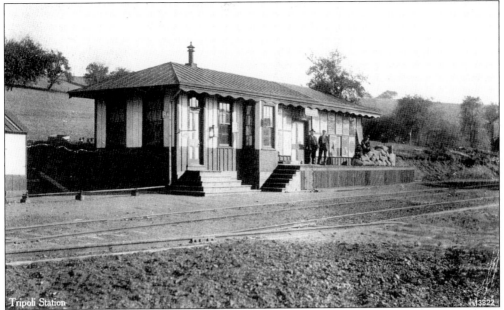

The New Tripoli Railroad Station of the Schuylkill and Lehigh branch of the Reading Railroad, known as the Berksy Line, was better known as Tripoli station. The original sign saying Tripoli is on display in the Lehigh County Historical Society Museum. The railroad transported dynamite and blasting caps for farmers in the 1890s. On March 25, 1898, for an unexplained reason, a shipment exploded in front of the station. The station was completely destroyed; but, because it exploded at night, no one was hurt.

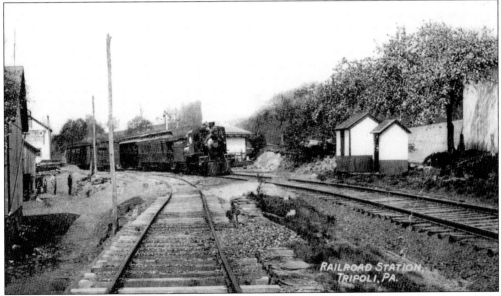

A steam engine with passenger cars is pulling into the Tripoli Railroad Station in this c. 1900 photograph. Area students took the train to Slatington to attend high school. The partial view of the white building on the left was a grain and potato warehouse used for storing product shipped by William Hoffman and later by his son Mark. The siding track in the foreground lead to an anthracite coal storage pit where carloads of Reading Anthracite Coal were unloaded.

63

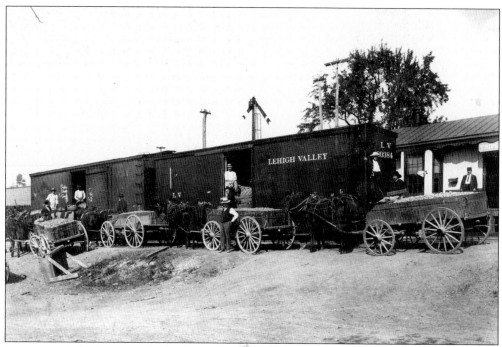

Farmers are bringing wagonloads of potatoes to Tripoli station. Potatoes were unloaded by hand into bushel baskets and carried onto boxcars to be loaded in bins for shipment. In 1900, William H. Hoffman succeeded B. N. Leiby in the grain, coal, and potato business, earlier established by his father, Elias Hoffman. William H. Hoffman built one of the largest shipping points on the Schuylkill and Lehigh Branch Railroad. In 1912, he shipped 161,000 bushels of potatoes or about 230 carloads. As many as 11 carloads were loaded and shipped in a single day.

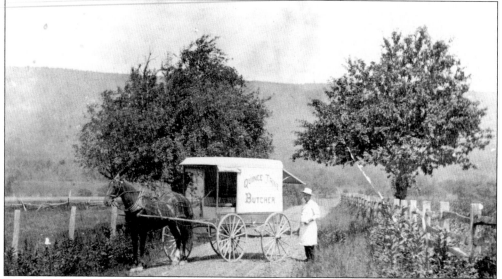

Butcher Quince Trine marketed his meat products farm-to-farm and door-to-door from his Rauch and Handwerk huckster wagon. He built a slaughter house on the present site of the Northwestern Medical Center in New Tripoli. George Jones owned the butcher business until it burned in 1942.

William Beck sponsored silent movies in New Tripoli. This handbill advertised movies. Charges are 15¢ for adults and 5¢ for children. In winter, the movies were shown in the community hall, a converted horse barn at the Blue Ridge Inn. The community hall was heated by a wood-burning parlor stove. In summer, the movies were shown outdoors at Ontelaunee Park.

MOVIES

Community Hall NEW TRIPOLI

FRIDAY, NOVEMBER 3, 1939
8 P. M.

JACK LaRUE in

I DEMAND PAYMENT

Hurricane Express, No. 5

SUNDAY MOVIES

Starting **Sunday, November 5th** Featuring

TIM McCOY in

"CODE of the CACTUS"

ADMISSION **15** and **5** Cents

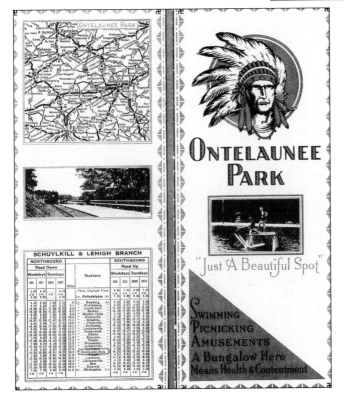

This Ontelaunee Park Railroad Schedule from the 1930s is for the Schuylkill and Lehigh Branch Railroad. The train ran between Reading and Slatington with a scheduled stop at Ontelaunee Park in New Tripoli. A convenient bridge was built over the Ontelaunee Creek to allow train passengers to walk directly from the station to the park.

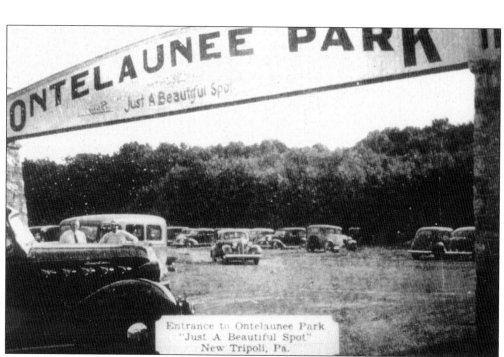

This is the original entrance to Ontelaunee Park. The Graham Paige car under the arch is Homer N. Snyder's personal car. Snyder owned the park from 1929 though 1966 when the parked closed. This is reminiscent of how the front parking lot looked on a Sunday or holiday in the 1930s and 1940s.

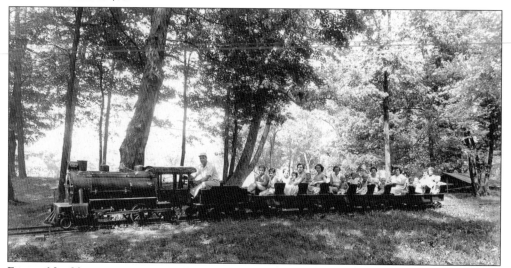

Engine No. 99 was a unique amusement ride that pulled a coal car plus three passenger cars at Ontelaunee Park. The train ran on tracks from the "tunnel," which also served as a storage shed in winter, along the Ontelaunee Creek, around the swimming pool, and through the shadows of the beautiful tall oak trees. It was a ride enjoyed by young and old when simpler pleasures made people happy. Frederick Mantz is the engineer and passengers on the train include, from left to right, Alice Snyder (née Loch), Erma Snyder (née Wassum), Violet Snyder (née Lutz), Marie Kistler (née Snyder), Susan Kistler, Sandra Greenwald (née Snyder), Sheila Stahley (née Snyder), and other unidentified riders.

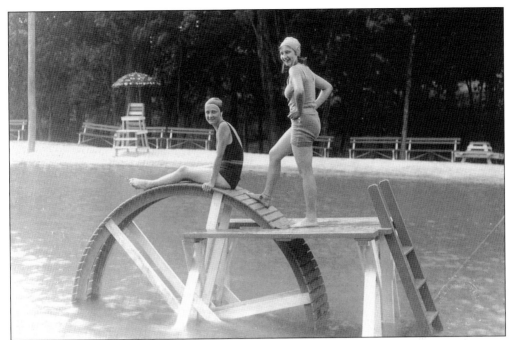

Marie Kistler (née Snyder) (sitting), daughter of park owner Homer N. Snyder, and Geraldine Parker (née Smith) (standing) were on the cover of the Ontelaunee Park brochure in 1930. The wooden waterwheel in the large sand-bottom pool was enjoyed by bathers as they rode on the waterwheel as long as possible before falling head first into the six-foot-deep water.

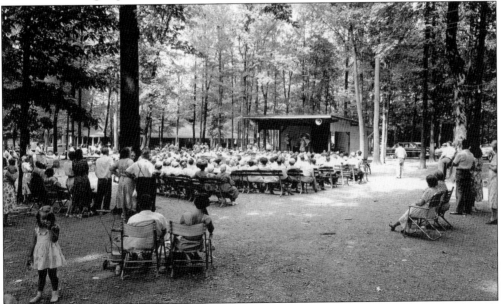

This is a typical Sunday or holiday crowd at Ontelaunee Park's shaded band shell (1930s through 1960). Free entertainment was provided by local and Nashville country and western bands and singers. Some notable entertainers included Willis Myers and his musical group, Dopey Duncan, Earl Keller and the Melody Rangers with the Promenaders and Little Jiggers, Shorty Long, and Sally Starr.

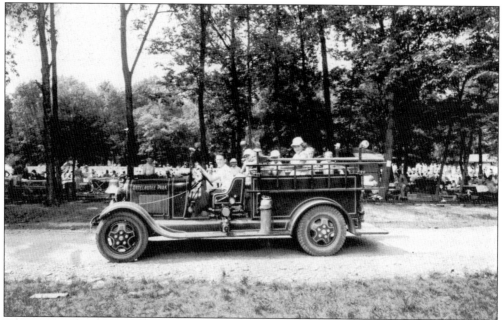

This Ford Model AA fire engine with siren was purchased in the 1950s by Ernest A. Kistler (son-in-law of park owner Homer N. Snyder) in Buffalo, New York, for Ontelaunee Park. Elwood Dotterer and his son Russell, owners of Dotterer garage in Wanamakers, refurbished and converted it into an amusement ride.

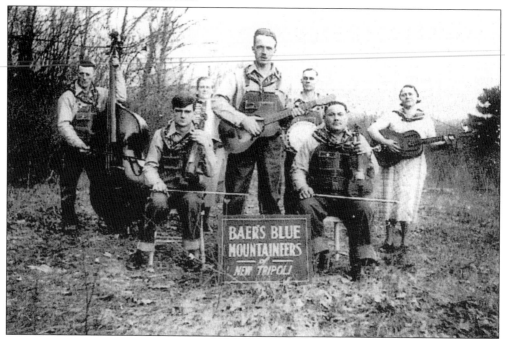

The Baer's Blue Mountaineers was a popular square dance musical group that entertained in the northwestern area. They played at community centers, parks, family reunions, picnics, and other special events. The musicians from left to right are Willie Baer, Samuel Baer, unidentified, Carl Follweiler, Floyd Bond, Robert Snyder, and Dorothy Bond (née Klingaman).

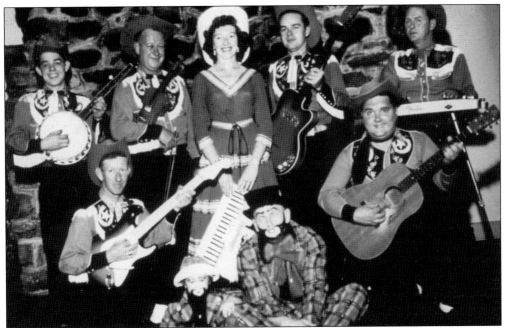

Earl and Ferne Keller with their Melody Rangers performed weekly on Allentown radio stations, Ontelaunee Park, church and fire company picnics, plus other social functions. The band expanded to include an adult square dance group known as the Promenaders and later a junior group known as the Little Jiggers. The band achieved notoriety appearing on national television. They were on Ted Mack's Amateur Hour in 1957 and won a national championship on November 7, 1958. From left to right are (first row) Harvey "Happy" Kressley, Brenda and Clenroy "Elmer" Geist (father and daughter comedians), and Allen "Shorty" Dotterer; (second row) Marvin "Pee Wee" Reichard, Earl and Ferne Keller (husband and wife), Gordon "Pickles" Long, and Warren "Lightning" Wertman.

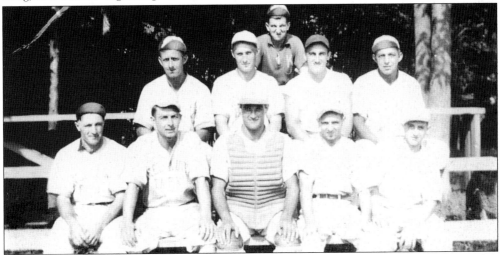

This is a 1935 photograph of the Ontelaunee Park baseball team. The team members from left to right are (first row) Luke Wuchter, Kermit "Shanty" Snyder, Freeman Wuchter, Warren Jones, and Ray Schellhamer; (second row) Russell Kerschner, Mark Wuchter, Herman Rauch, and Lawrence Greenawalt. The person on the top is unidentified.

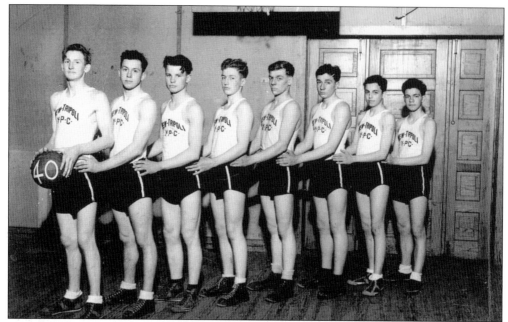

Ebenezer Church had a youth basketball program in the 1940s and 1950s. The YPC on the player's shirts stands for Young Peoples Council. Team members from left to right are Daniel N. Snyder, Willard A. Kistler, Emil Rash, Carl D. Snyder, Herman M. Zellner, Earl Zellner, Mark W. Mantz, and Francis D. Leiby.

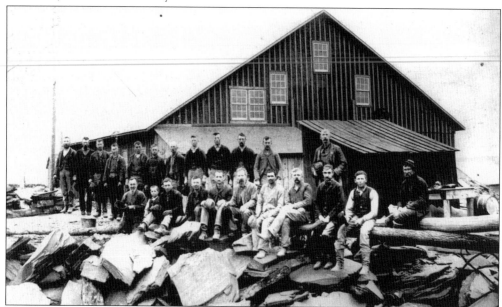

This photograph of the workers at the Lieberman Slate Quarry was taken in the 1890s. The quarry was in Slateville. From left to right are (first row) Ike Correll, Ike Correll Jr., Frank Deibert, William Roberts Jr., Sam Lutz, Tom Jones, George Lutz (brother of Sam Lutz), Levi Hemerly, Billy Foulk Daniels, Bill Bailey, and Amandes Creitz; (second row) unidentified, William Roberts Sr., Elmer Lutz, John Griffith, Harvey Sechler, William Griffith, Edwin Follweiler, Nelson Miller, Henry Roberts, unidentified, unidentified, and Monroe Miller.

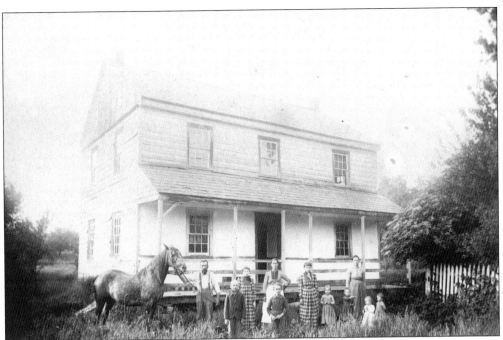

The log house built in 1837 by John Bennighoff near Mossersville forms the background for the family gathering of Franklin Bennighoff and Leanna Bennighoff (née Zellner) just prior to a tragedy that struck the family. In 1882, a very contagious illness affected the family resulting in the death of Leanna and four of the children. The house, complete with all furnishings and personal belongings, was abandoned and not entered for many years fearing contamination.

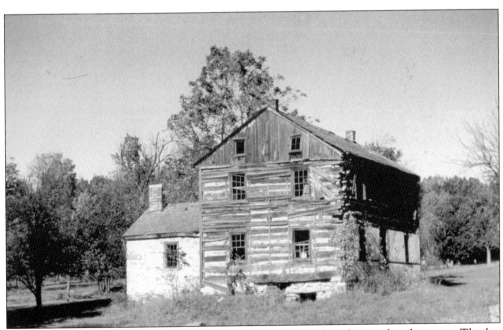

This is a view of the Bennighoff house after 75 years of neglect due to abandonment. The log walls and one-story stone kitchen can be seen before the house was disassembled in the 1960s.

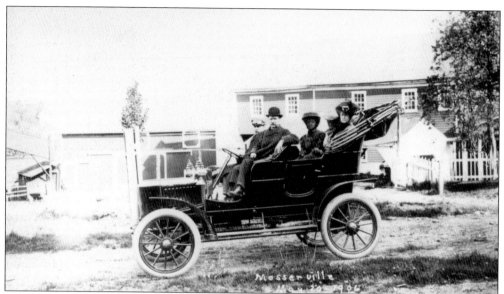

Granville Mosser Snyder and family are in front of the Mosser Gristmill in their touring automobile on May 20, 1906. The village, which became known as Mossersville, was established by the Mosser family. It consisted of a store, post office, several houses, and the gristmill.

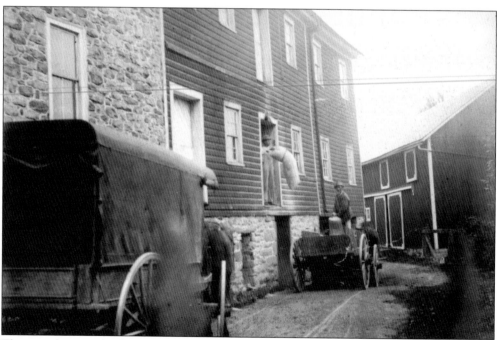

This is a photograph of Mosser Gristmill in Mossersville. Local farmers brought their grain to be ground into animal feed. Philip Mosser built his first mill in Lynn Township around 1754 when the American Indians were friendly with the Mosser family. It is said that the American Indians marked the corners of the Mosser property so other traveling tribes would not harm any member of the family. Philip's son David rebuilt the mill in 1817 and added a sawmill. The mill was continuously operated by the Mosser family through the generations until 1949.

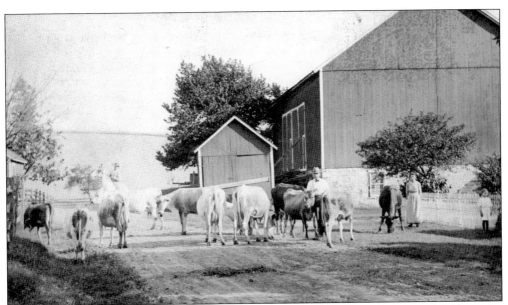

Herding cattle was an important job on area farms as fences were erected around fields, yards, and gardens to keep animals out. Here dairy cows are peacefully grazing along the roadway as the Allen Kistler family of Mossersville watches over their herd. The horseback rider in the background prevents the cattle from wandering too far astray.

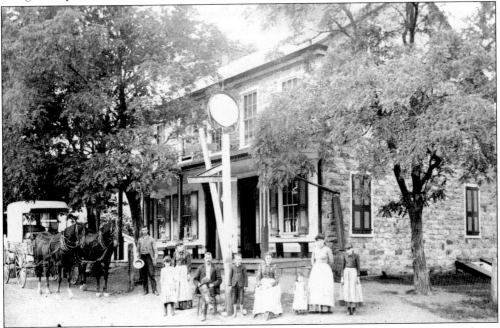

This late-1800s photograph shows Henry J. and Mary A. Rabert seated in front of the Rabert's Corner Hotel, which they owned and operated from 1878 until 1889. The couple was married in 1877 and purchased the hotel in 1878, at which time they changed the name of the area to Rabert's Corner from Oswaldsville. The hotel earlier housed a post office for two years until it was moved to Mossersville in 1866. Susan German operated a store in the same building from 1881 until 1884. Henry and Mary also farmed a 35-acre farm.

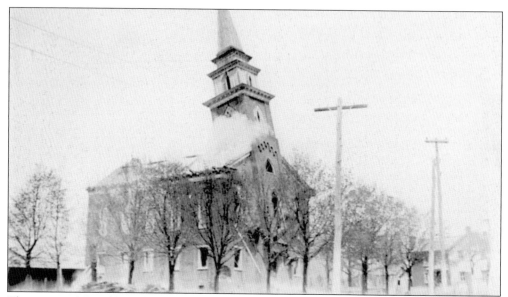

The razing of the old Jacob's Union Church in 1924 was done in preparation for construction of a new stone church. The new church was the fourth church on the same site in Jacksonville. The congregation planned to build in 1914, but World War I delayed the project. The first, a Reformed church, was a log structure built in 1761. The second church was a union church (Reformed and Lutheran) built in 1807, and dedicated in 1808. The third church was of brick construction, erected for a cost of $6,500 and dedicated in 1863. The fourth and current church is of stone construction and was dedicated on August 21, 1927.

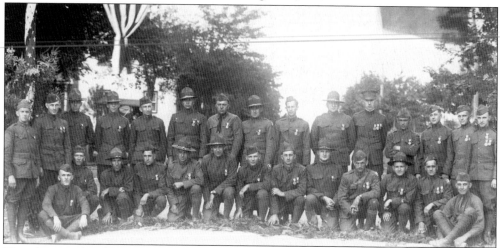

This photograph, taken at Jacksonville Church in June 1919, was at a welcome home celebration held for returning World War I veterans. Oscar Henry designed and painted the Lorraine cross emblem of the 79th Division and the keystone badge of the 28th Division. The veterans included from left to right are (first row) Urben Heintzelman, Thomas Kramer, ? Gross, Claude Reinhart, Howard Gernert, Mark Hoffman, Charles Hermany, Felix Faust, Solomon Hermany, Victor Feinour, Harold Weiss, Robert Derr, and Ralph Sittler; (second row) Robert Hartman, Arthur Snyder, Marten Fetherolf, Paul Ebert, William Knepper, George Oswald, Alvin Snyder, Edwin Bond, Oscar Henry, Charles German, Herbert Long, Dewie Fetherolf, Charles Miller, Ed Fetherolf, and Ralph Horn.

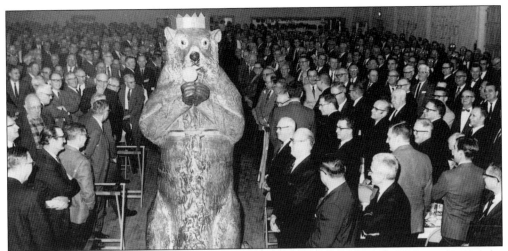

King Groundhog is munching on a head of cabbage while making his grand entrance at the *Fersommling* gathering on February 2, 1968. World War I caused many Americans to become suspicious of the Pennsylvania Germans and resentful of anyone who spoke German. There was a general decline in the dialect. By 1933, many prominent farmers, business men and professionals saw a need to preserve the Pennsylvania German dialect and heritage. They adopted the groundhog and Groundhog Day as a reason for getting together to celebrate and speak only the Pennsylvania German dialect. Every English word spoken cost a penalty of 10¢ a word (now 36¢) which is donated to Easter Seals. The first Fersommling was held on February 2, 1934.

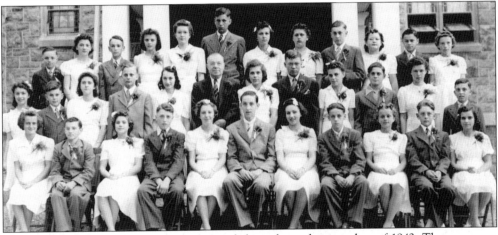

Here is an image of the Lynn Township eighth-grade graduating class of 1942. The ceremony was held in the front of Jacksonville Church in Jacksonville. The graduates from left to right are (first row) Marion Metzger, Willard Gernert, Anna Sittler, Ralph Miller, Emma Boger (née Fritzinger), Herman Kramer, Ruth Bittner (née Bennicoff), Russell Oswald, Anna Belle Klingaman, Robert Hartman, and Shirley Schellhamer (née Kindt); (second row) Marie Bachman (née Hamm), William Hollenbach, Eleanor Snyder (née Fister), Wayne Hermany, Helen Hermany (née Hartman), Mervin Wertman (superintendent), Ruth Fenstermaker, Floyd Kistler, Geraldine Wesoloski (née Kern), Terry Stewart, Betty Jane Hermany (née Hamm), and William Gackenbach; (third row) Paul Billig, Anna Wendling (née Scheirer), Nobel Leiby, Mildred Feinour (née Peters), Irene Dietrich (née Hamm), Russell Hollenbach, Pauline Sittler, Alice Oswald (née Hermany), Nevin Snyder, Dorothy Fetherolf, George Weida, and Lenore Heckman (née Feinour).

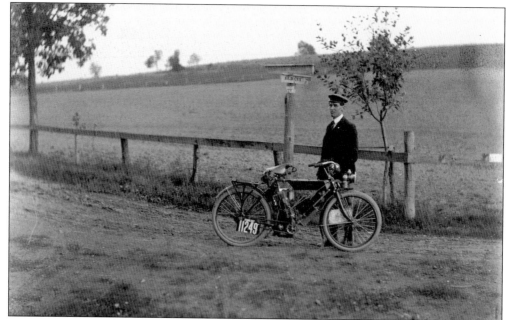

This photograph of a telegram messenger from Wanamakers with his motorbike was captured in 1907. The messenger delivered telegram messages to people in the rural communities and farms where there were not yet telephone lines. The photograph was taken by Claude Reinhart, a merchant and commercial photographer.

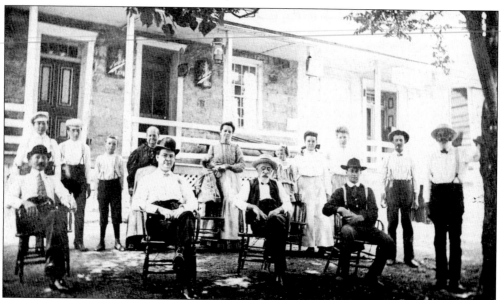

The Lynnport Hotel was located along present day Route 143 in Lynnport, Lynn Township. Locals and visitors posed for this photograph in front of the hotel. Currently a private residence, this hotel was the site of the first Lynnport Fire Company turkey raffle held shortly before Thanksgiving beginning in 1944. Live turkeys for the raffle were kept in a small storage shed behind the hotel.

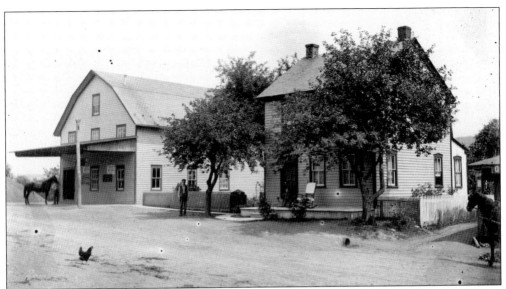

This is the residence and potato warehouse of A. P. Fidler in Wanamakers. The railroad tracks ran immediately behind the house and warehouse. The Wanamakers railroad station was located a short distance to the right of this photograph. A rooster is standing in the middle of the road.

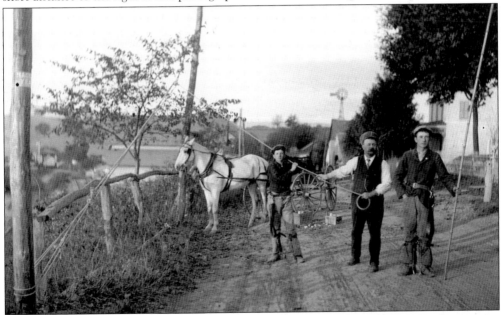

This photograph was taken around 1910 in the village of Wanamakers. The man in the center is Anson A. Fister of Krumsville of the Kutztown Rural Telephone and Telegraph Company. Fister and two of his work crew are erecting telephone lines. This is the first time the community had any kind of communications other than telegram services located at the Wanamakers railroad station. The company received its charter September 5, 1908, and Fister served as the first president. Years later, attorney Wilson Wert succeeded Fister. Today all parts of the original company have become part of the Verizon network. It is interesting to note that some of the Pennsylvania Germans were reluctant to use the phone thinking only the English language could be transmitted.

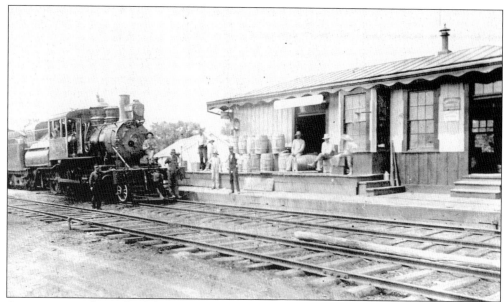

A steam-powered camelback locomotive and freight train is pulling into the Wanamakers station between 1890 and 1900. The station was completed in 1874 with a grand opening on June 18, 1874. Ironically, nine days after the station was opened the owners filed for bankruptcy. The Berksy made its last official run on April 9, 1949. Today the railroad continues to be operated as a tourist railroad between Wanamakers and Kempton known as the WK&S, which stands for Wanamakers, Kempton and Southern.

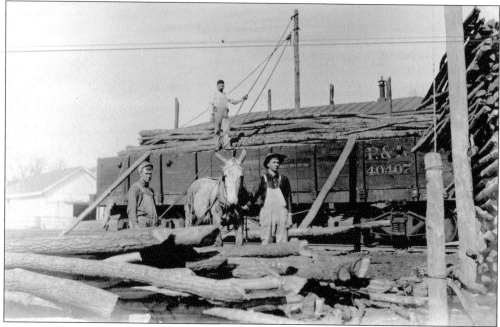

Logs were being loaded onto a gondola car at the Wanamakers station siding. The logs cut in the local area were destined to be used as mine timbers for shoring up the ceiling in the coal mines over the Blue Mountain. John Schaffer is on the railroad car and Charles Winter is leading the mule. The men are using a mule with a pulley system to load the logs.

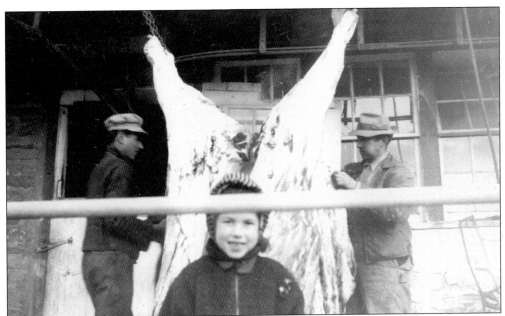

Butchering time at the farm of Earl Henry and Meda Henry (née Hamm) along Route 863 in Kistler Valley was an anticipated event. Local farmers usually butchered during the winter, taking advantage of the colder temperatures to keep the meat from spoiling. Most farms had a smokehouse used for smoking hams, bacon, sausage, and dried beef. In this picture, Clarence Weida and Earl Henry are seen skinning and splitting a steer. Nancy Weida is seen in the foreground.

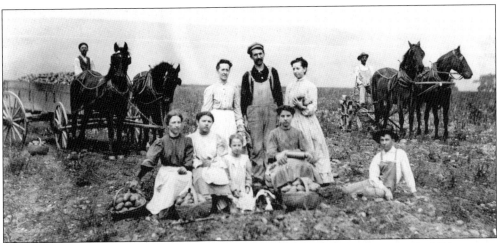

In this 1907 photograph, taken on the James Donat farm, men, women, and children were helping to harvest potatoes. The pickers kneeling on the ground are proudly displaying baskets full of very large potatoes. The team of horses on the right was hitched to a potato digger (driver unidentified) and the horses on the left are hitched to a wagon loaded with freshly picked potatoes (driver unidentified). The load of potatoes was taken back to the barn or directly to the railroad station for sale. Potato harvesting usually lasted about a month and was the best cash crop for farmers in the area. The pickers from left to right are (first row) Minnie Follweiler, Hattie Donat, Emma Shwitzinger, Bertha Lutz, and Edwin Donat; (second row) unidentified, Zeph Shwitzinger, and unidentified.

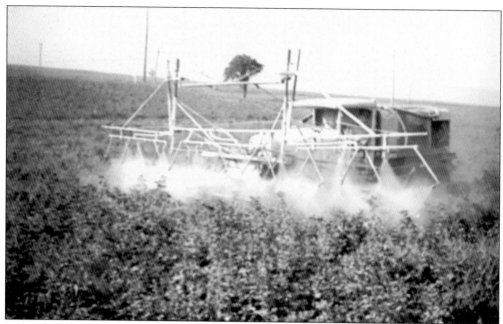

Grummbiere am schpraya, Earl Leiby is "spraying potatoes" on his father Milton's farm in this early-1940s photograph. The farm was located north of Wanamakers at the base of the Blue Mountain. The John Bean sprayer was mounted on the back of an old Ford Model A truck and sprayed eight potato rows at a time. The sprayer was powered by a four-cylinder Continental engine.

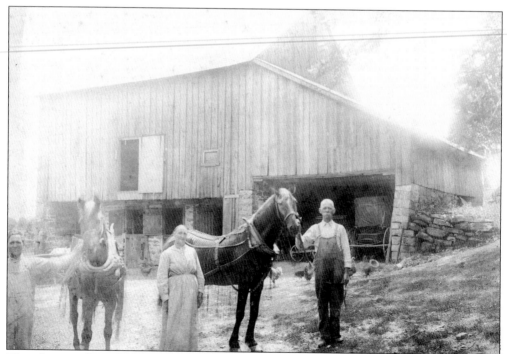

This photograph is of, from left to right, Fred, Kate, and William Hunsicker outside their barn on the farm at the foothills of the Blue Mountain. Note the fly net harness on the horses.

The home of August Bethke and his companion Abigail Frey was located on a two-acre tract of land at the base of the Blue Mountain north of Wanamakers. All that remains of the original house are stonewalls and the foundation. August Bethke was born on June 26, 1837, in Estonia. He was a skilled wood carver who made spoons and kitchen utensils. It is believed that Bethke came to America when he escaped from Estonia during the Franco-Prussian War. When Bethke died on February 14, 1913, he had no known relatives. Abigail Frey continued living in the house for several more years until the house burned in a fire. The fire was believed to have been accidentally caused by Frey who smoked a clay pipe.

This funeral bill was prepared by Charles G. Greenawald, undertaker, for the funeral of August Bethke on February 17, 1913. Bethke was buried in Potter's Field at the southern end of Jacob's Church Cemetery, Jacksonville. Greenawald's cabinet making and undertaking business located in Steinsville was later taken over by Samuel Nester.

81

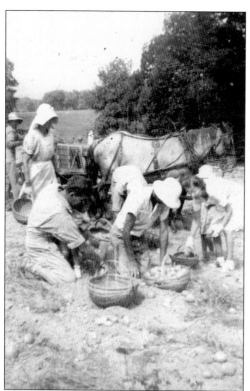

Pickers are busy picking potatoes on the Viola and Frank Hamm farm just north of Lynnport. On the extreme left is Frank Hamm; Viola Hamm is in a sun bonnet. In the foreground from left to right are Albert Rauch holding his son David, Clark Hamm in helmet with Stewart Hamm directly behind, and Helen Rauch (née Hamm) with her daughter Janet behind her. Although horses were still used in the mid-1940s on Lehigh County farms, a close look behind the wagon will show the exhaust, air cleaner, and steering wheel of a 1939 Farmall H tractor.

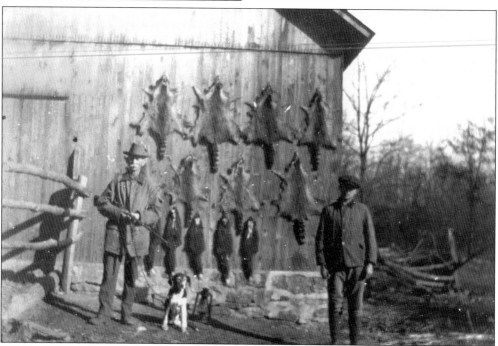

William Franklin "Raccoon Bill" Hunsicker and his grandson, Paul Leibensperger, are seen here. William was a "coon" hunter. The photograph was taken on the farm at the foothills of the Blue Mountain.

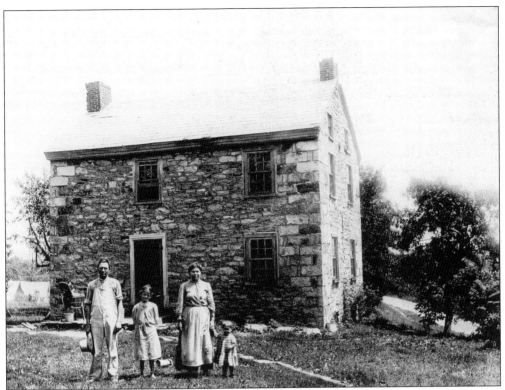

Fred and Cora Hunsicker's house, seen here around 1915, is located on the corner of Lentz and Gun Club Roads in Lynn Township. The family members from left to right are Frederick Daniel Hunsicker, Gertie Hess (a neighbor), Cora Sally Hunsicker (née Ulrich), and Salome Cora Hunsicker (daughter).

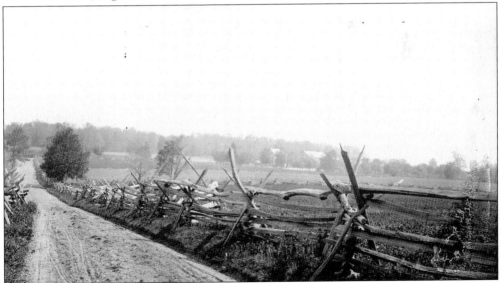

This 1890s photograph of a zigzag post and rider fence, or *staugge fens* in German, is constructed along both sides of a dirt road. The fence was used to keep farm livestock in or out of an area. The dirt road is now known as Hunters Hill Road.

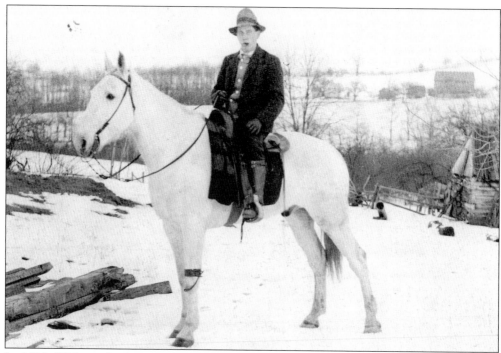

In 1920, Webster Snyder is riding his *schimmel gaul*, which means "white horse," after a mid-winter snowstorm. The farmhouse and barn in the background were owned by Leon Rumfield and Edna Rumfield (née Heilman).

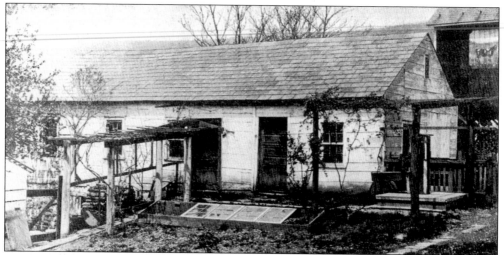

Frederick Leaser's log house near Wanamakers was built prior to 1755. Leaser came to America from Switzerland with his father, Jacob, in 1746. Leaser served in the French and Indian War when he was only eight years old and later in the Revolutionary War. Frederick transported farm produce in a Conestoga wagon to Philadelphia. On September 15, 1777, while on a trip, his wagon and team of six horses were commandeered by the Continental Army to transport the Liberty Bell to Allentown for safekeeping as the British were preparing to invade the city. Leaser rose to the cause and gave assistance. The bell was loaded on his wagon and taken to Allentown. Three families (Leaser, Mickley, and Haupt) all claim credit for hauling the bell.

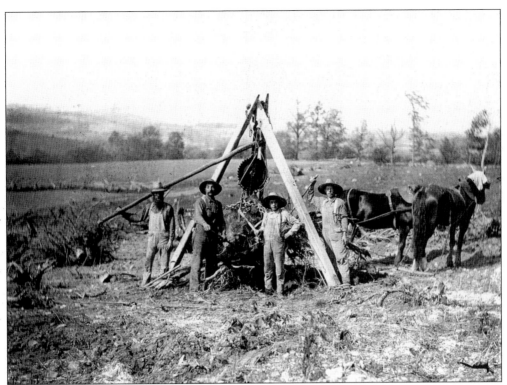

This 1910 photograph shows an improvised pulley system devised by farmers for removing tree stumps to clear the land for farming. The hard working farmers from left to right are Willoughby Snyder, Charles Mantz, unidentified, and James Snyder.

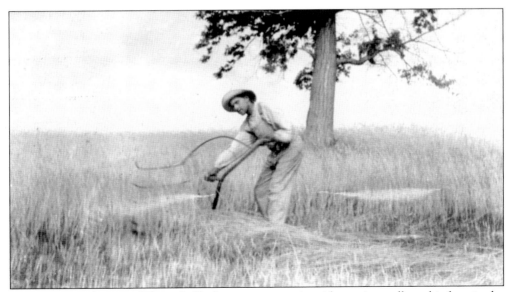

William A. Kistler, son of Elmer C. Kistler, is cutting grain with a grain cradle on his farm in the Kistler Valley, Lynn Township around 1913. The straw with the grain still attached was tied into sheaves and later collected for threshing.

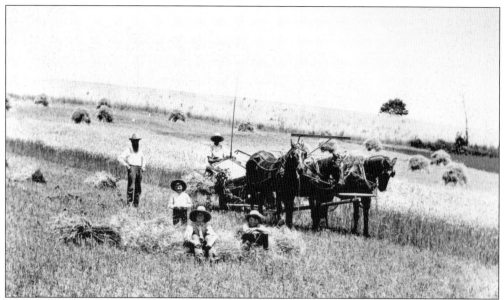

This early-1900s photograph depicts harvesting wheat with a team of three draft horses pulling a grain binder. The stalks of grain were tied into sheaves, which were then stacked into shocks and capped with an additional sheaf to prevent rain damage. The shocks were left in the field to dry. Later they were hauled home to the barn and threshed. The man standing is Willoughby Snyder, the man on the binder is Charles D. Mantz, and the children from left to right are Clarence, Floyd, and Clayton Mantz.

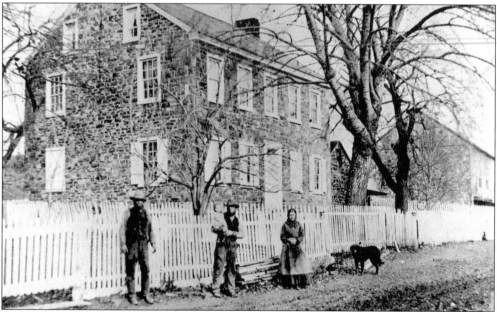

Seen in the 1880s, the Bausch family is standing in front of their new stone farmhouse located on Bausch Valley Road in Lynn Township. The original homestead is located between the new house and the barn. From left to right are Stephen Bausch (1838–1911), Joseph Bausch (brother of Stephen) (1829–1910), child Mary Weiss (née Bausch) (1883–1971), Ida Bausch (née Werley) wife of Stephen (1864–1928), and the family dog.

One of oldest continuously operating mills in the region was the Bausch-Betz Mill. The mill was constructed of logs by Heinrich Bausch along Sweitzer Creek in Lynn Township before the American Revolutionary War. During its operation the mill served both as a gristmill and sawmill. Water for the mill came from a millpond. Around 1900, the pond was replaced with a mill race, which ran parallel to Sweitzer Creek for about a mile. Sawmill operations ceased in 1905. The gristmill remained in operation using water as its source of power until 1931 when it was electrified. The mill closed in 1955. During the 1970s a group of industrial engineers from the Smithsonian Institution surveyed and documented the machinery in the mill.

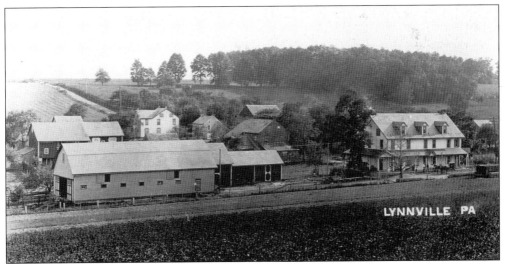

In this c. 1900 photograph of Lynnville, the white building on the right houses a general store, post office, and hotel. William F. Brobst, proprietor, provided a rest stop for weary travelers. The barn on the left was used as shelter for patron's horses and also as a livestock auction house for many years. The auction house offered a place where farmers bought and sold horses, cows, and hogs.

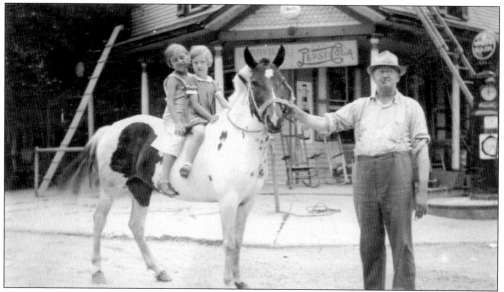

Here in 1939, George Balliet, owner of Lynnville Sales Stables, stands in front of the Lynnville Hotel. Sitting on the horse are Gladys Miller, daughter of Harvey and Annie Miller owners of the Lynnville Store, and Anna Mae Laudenslager, granddaughter of George Balliet. Balliet was a livestock and horse dealer who shipped animals by rail to the New Tripoli Station. The animals were walked from New Tripoli along Schochary Road to Lynnville Sales Stables to be sold.

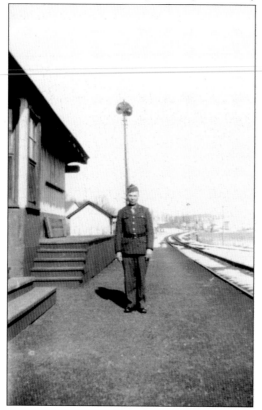

Like thousands of other Americans, many Lynn Township residents went off to war in the 1940s. Here Lynnport resident Paul Mantz poses in his dress uniform in front of the Lynnport Railroad Station. The station has long since been torn down. It used to stand across the street from the present-day Lynnport Fire Company.

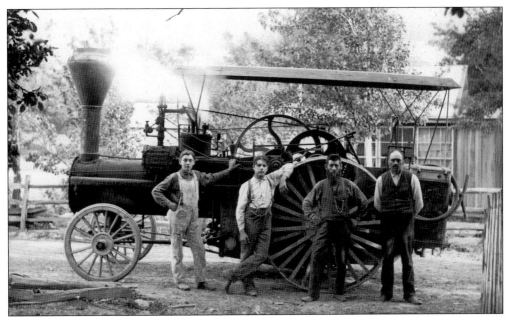

This photograph of Willoughby Snyder's Frick 15 horsepower steam engine tractor was taken around 1905. The tractor was built in Waynesboro. Willoughby used the tractor to operate a grain threshing machine and to power his sawmill and carpenter business. Left to right are two pairs of fathers and sons, Ralph D. Snyder (1886–1914), Isadore Lauchnor (1880–1931), Willoughby Snyder (1851–1914), and William Lauchnor (1855–1929). The photograph was taken by another of Willoughby's sons, James D. Snyder (1874–1932).

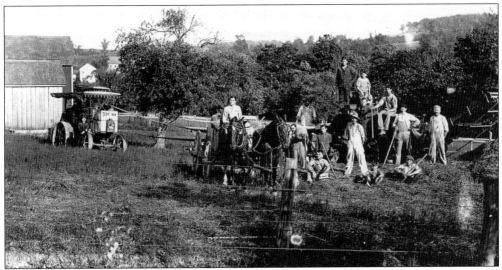

Grain threshing was done during the hot summer months. Nathan H. Snyder's Huber steam tractor and threshing rig were brought to thresh the grain on his nephew James D. Snyder's farm. Paul C. Snyder can be seen at the wheel of tractor and Arthur D. Snyder is standing high with the all-important oil squirt can in his hand. Brothers Arthur D. and Paul C. Snyder did custom threshing with their father's threshing rig. Very few farmers had their own threshing rig. This 1910 photograph was taken by professional photographer James D. Snyder.

This barnyard scene was taken at the Nathan H. Snyder farm on February 12, 1918. From left to right are Henry Smith, holding his daughter Evelyn; Ellen Snyder (née Stump), also known as Mrs. Nathan Snyder; Mary Smith (née Snyder), daughter of Nathan and Ellen Snyder; Verna Wink; Ella Wehr Kunkel (née Snyder), holding Miriam Snyder; and Edna Snyder (née Kunkel), also known as Mrs. Paul Snyder. The men in the barnyard are Paul C. Snyder (left) and Arthur D. Snyder.

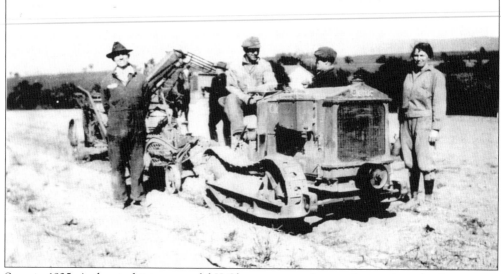

Seen in 1925, Arthur is driving a model K Cletrac tractor that used a steering wheel to turn it. The tractor pulled a potato digger with a harvester attached that conveyed the potatoes right into a box wagon along side pulled by a team of draft horses. From left to right are Clayton Snyder of J. M. Snyder Incorporated Farm Equipment Dealer; Raymond D. Mantz, mailman in dark suit; Arthur D. Snyder on the tractor; Norman Peter, hired man; and Anna Snyder (née Delong), wife of Arthur.

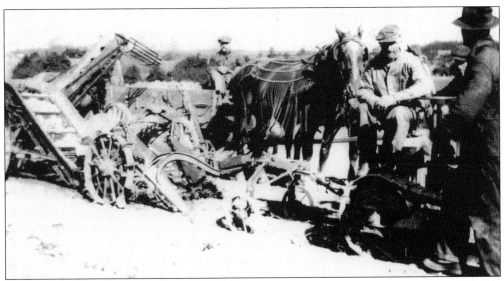

In 1925, Arthur Snyder is testing the farm machinery consisting of a model K Cletrac tractor pulling a potato digger with an attached elevating chain conveyor. The purpose was to dig potatoes, separate the soil, and load the potatoes into a wagon. The experimental harvester was tested on the Snyder farm, but it failed to separate the potatoes from the soil due to the gravel-type ground. The dealer later sold the equipment in an area where they had sandy soil. In the photograph are Norman Peters on the wagon, Arthur D. Snyder on the tractor, and Clayton Snyder to the far right.

In 1928, a single engine airplane crashed in a 20-acre field on the farm of Arthur D. Snyder. No one knows how this freak accident happened, but the plane hit the only tree in the middle of the field. Planes were still a rare occurrence in 1928 and many people came to see the crash. Carl Snyder still has the wing lights from the plane.

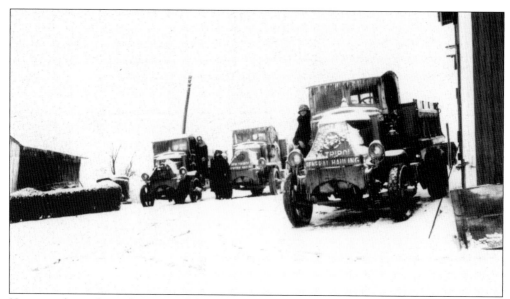

Here are three chain driven "Bulldog" Mack AC solid tire trucks owned by Arthur D. and Paul C. Snyder of Snyder Brother General Hauling. From left to right are Cora Strauss, Mabel Woodring, and Anna F. Snyder, wife of Arthur Snyder. The Snyder brothers created another company known as Blue Ridge Stone Company, which established a steam powered stone crusher on the Blue Mountain. Company operations ceased in 1937 when the Works Progress Administration (WPA) started crushing stone for road construction themselves.

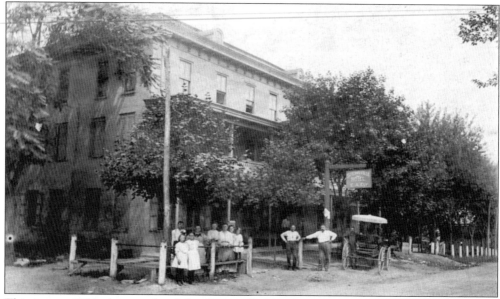

This is a c. 1905 photograph of the Steinsville Hotel in the northwestern corner of Lynn Township. The hotel was the center of activity in that region containing a general store and post office. Many of the rooms were rented by workers who labored in the nearby slate quarries. The hotel today is at the intersections of Steinesville Road and Blue Mountain House Road.

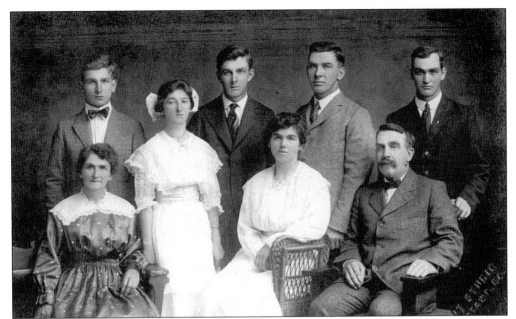

This family portrait of the Nathan H. Snyder family was taken around 1910. From left to right are (first row) Ellen Snyder (née Stump), Ella Snyder, Mary Snyder, and Nathan H. Snyder; (second row) sons Paul C. Snyder, Arthur D. Snyder, Homer M. Snyder, and stepson John Wink. Nathan was a potato farmer, potato shipper, owner of the horse team used by the New Tripoli Band wagon, and one of the founders of the New Tripoli National Bank.

George O. Weida holds the harness of Shep the dog as Dorothy Moyer (née Weida) holds Nancy Weida before giving Nancy a wagon ride in 1939. The farm near Stines Corner was owned by Owen Weida and Mary Weida (née Werley), Nancy's great-grandparents.

Clarence Weida stands with his sled and dog during the winter of 1921. The photograph was taken on the family farm along Schochary Road in Stines Corner. It looks like his mother prepared him well for the snow with his cap, snowsuit, and boots to keep him warm.

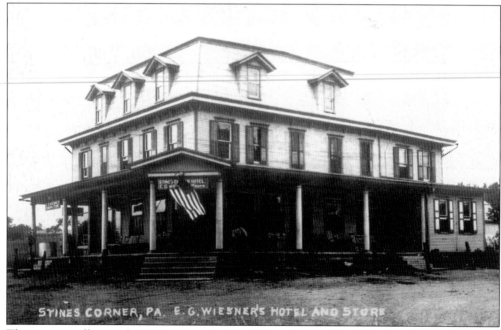

This is an excellent early-1900s postcard of the Stines Corner Hotel. The hotel was established around 1855 by Simon Lentz. Lentz operated the hotel for 10 years. Subsequent owners have included William Stine, John and Charles Peter, ? Hoffman, Elias Wiesner, and a Mr. Zerfass. A store was opened in the building in 1874 and run by William Stine. A post office was opened a year later with Joshua Weida acting as the postmaster. The village called Stines Corner was named after William Stine.

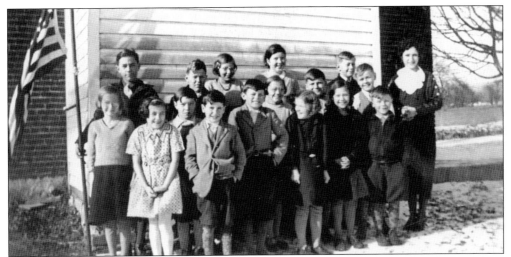

Mildred Hamm, school teacher, is photographed with her Bausch's School class of 1936. From left to right are (first row) Helen Kunkel (née Baush), Joyce Hamm (née Bittner), Stewart Follweiler, Robert Follweiler, Annabell Zellner (née Snyder), Dorothy Lochner (née Herman), and Earl Kerschner; (second row) Paul Hartman, Dorothea Dotterer (née Holben), William Bausch, and James Snyder; (third row) Herman Kerschner, Paul Snyder, Marie Fritzinger (née Baush), Ida Hartman, and James Hunsicker.

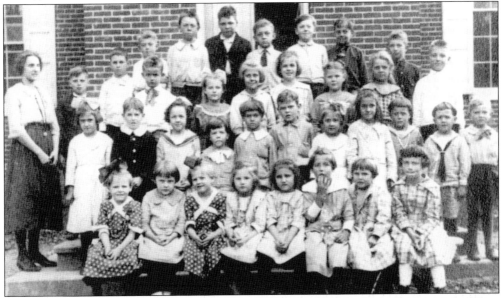

Arlene Loy and her 1921 class in the New Tripoli School are shown here. Students from left to right are (first row) Lillian Everett, Ruth Lauchnor, Ruth Everett, Evelyn Faust, Marian Faust, Margaret Greenawald, Marian Lauchnor, and Maria Snyder; (second row) Zenith Mosser, Lawrence Lauchnor, Helen Ebert, Bob Kerstetter, Alfred Schaeffer, William Bleiler, Constance Mosser, Ida Ward, Stewart Lauchnor, Ralph Ebert, and Alfred Bleiler; (third row) Arlene Loy Werley, Lawrence Miller, Lawson Sittler, Russell Kerschner, Cleonice Bleiler, Mildred Althouse, Reba Snyder, Velma Sittler, Helen Weaver, and Lawrence Snyder; (fourth row) Norman Sittler, Alvin Weaver, Robert Scheduler, Lawrence Greenawald, Earl Lauchnor, Randall Snyder, and Luther Fritzinger.

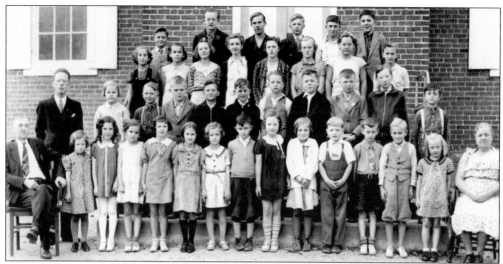

This is the Steinsville School class of 1937. From left to right are (first row) Arthur Klingaman (teacher), Doris Werner (née Follweiler), Ruth Fritz (née Kistler), Shirley Kindt, Dorothy Heffner, Ella Mae Hermany (née Snyder), Marie Bachman (née Hamm), Nevin Follweiler, Nancy Reinhart, Ruth Hartman, Frank Daniels, Arlan Kunkel, ? Geisinger, Jean Sheffler, and Jennie Foster (teacher); (second row) Melvin Brobst (teacher), Mae Kramer, Charles Nester, Russell Hartman, Charles Donat, Warren Heffner, unidentified, unidentified, Milton Hartman, Paul Arndt, and Thomas Donat; (third row) Pauline Kindt, Lorraine Kindt, Jean Schmoyer, Luella Hamm, Ruby Bond, Viola Knepper, Helen Leiby, and Irene Donat; (fourth row) Earl Leiby, Lester Heffner, unidentified, Paul Heffner, John Donat, and Clifford Kramer.

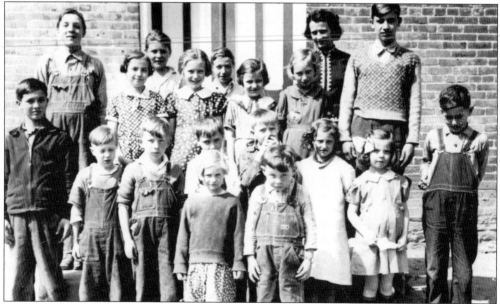

This photograph is from Camps School, Lynn Township, in 1937. Students from left to right include (first row) Virginia Snyder and Kenneth Gruber; (second row) Harold Bauscher, Paul Snyder, Henry Gruber, William Frey, Ralph Bauscher, Elsie Snyder, Joan Snyder, and Melvin Camp; (third row) Luther Kramer, Mae Bittner (née Smith), Lee Oldt, Leonia Kunkel, Forrest Smith, Jean Camp, Beatrice Frey, teacher Marie Kistler (née Snyder), and William Snyder.

Four
WEISENBERG TOWNSHIP

Weisenberg Township was established on March 20, 1753, at Easton, the county seat of Northampton County. It was a part of the territory purchased by Thomas Penn in September 1737 from the Lenni-Lenape tribe of the Delaware American Indians through the famous and dishonorable Walking Purchase. The township became a part of Lehigh County when it was separated from Northampton County on March 6, 1812. The township is six and a half miles long by five and a half miles wide, and consists of 17,167 acres.

The area was settled by Germans who arrived in America through the port of Philadelphia. Their language, spoken for the first 200 years, was a German dialect today known as Pennsylvania Dutch or Pennsylvania German.

The settlers were of the Lutheran and Reformed faith and churches were established immediately upon their arrival. Original churches were Ziegels Union and Weisenberg Union, where both faiths practiced their religion with a common bond to God. Churches later established were St. Paul's Union at Seiberlingsville in 1857 and Zion United Brethren in Christ at Seipstown in 1876.

The community over the years included normal business establishments such as general stores, taverns, gristmills, tanneries, blacksmiths, distilleries, and a carriage and wagon works. Farming, however, was the basic industry for the first 200 years of the township's existence.

Early schools were a part of the church organization and were conducted entirely in German. One-room schools were built in each area of the township after the common school system was adopted. These one-room schools were closed in 1951 when Weisenberg Elementary School was built.

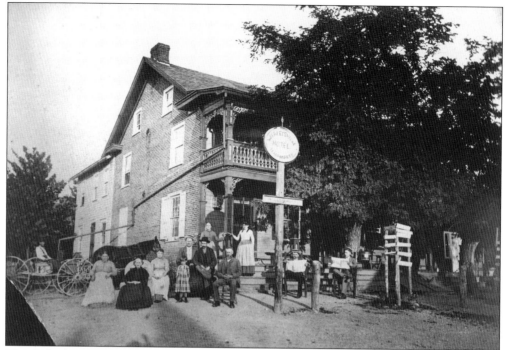

The Seiberling Family established a tavern at this site in the late 1700s. The building was replaced by Elias Werley in 1865 and the village became known as Werleysville and later as Werleys Corner. Here Elias Werley, his wife Leanna, and their sons Oscar and Harvey pose with their families.

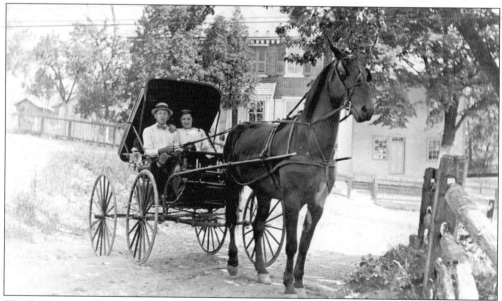

This horse-drawn buggy is carrying Milton Zimmerman and Sadie Hamm during their courting days. They were married on February 19, 1914, at the home of Rev. W. L. Meckstroth. The photograph was taken in front of the home of Milton's mother, Emma Zimmerman (née Balliet), along Carpet Road.

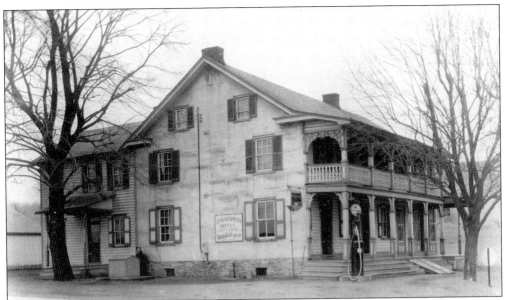

Milton and Sadie Zimmerman owned and operated the Werleys Corner Hotel from December 4, 1915, until it was closed by their son Sterling on July 13, 1994. Steer and turkey raffles, as well as community dances, were held at the hotel but were discontinued prior to 1940. The wedding reception of Sterling Zimmerman (son of Milton and Sadie) and Florence Smith was celebrated here in late December 1944. Gloria Zimmerman (daughter of Sterling and Florence) donated the hotel and grounds to the Weisenberg-Lowhill Historical Society in September 2003.

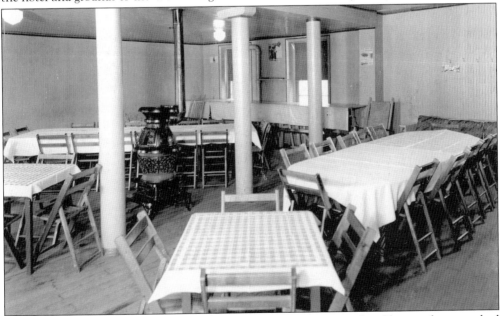

This is the banquet room of the Werleys Corner Hotel. To maintain a hotel license the owner had to provide a banquet facility, furnished rooms, and serve food. A common practice was to serve meals following a funeral. Saturday night auctions and dances (frolics) were held in this room. Two of the musicians who played were Granville Adam and Phaon Gehringer. A pot-bellied stove heated the room.

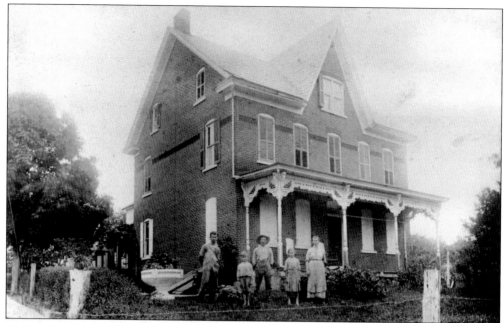

This *c.* 1915 photograph was taken in front of the farm of John David Baush and Sarah Baush (née Klotz) located along the cement pike between Werleys Corner and Lynnville. From left to right are Mark Adolph Baush (1897–1949), Ray Elvin Baush (1909–1994), John David Baush (1863–1942), Verna Grace Baush (1903–1972), and Sarah Baush (1873–1944). Sarah was John David's second wife. His first wife, Louise Baush (née Mosser), died in 1905. The house was built with bricks that John David hauled in his wagon from the railroad station in New Tripoli. Stones for the foundation were dug from two quarries on the property. The farm was later owned by Henry David Baush and Jenny Baush (née Hamm) and subsequently by Miriam Sarah Wisser (née Baush) and her husband Herman L. Wisser.

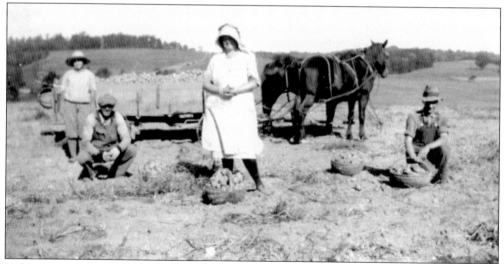

Picking potatoes in 1920 on the farm of George Balliet and Minnie Balliet (née Hamm) was a formidable annual fall task. Horses were used to pull the Rauch and Handwerk wagon loaded with potatoes into the barn for storage. Seen from left to right are unidentified, Bob Hoodmacher, Annie Laudenslager (née Balliet), and Luther Laudenslager.

Posing in 1944 at the George and Minnie Balliet home along Holbens Valley Road is Andrew Hamm and five generations of his family. Seated is Andrew Hamm holding his great-great-granddaughter Darlene Hoffman (née Laudenslager). Standing from left to right are his daughter Minnie Balliet (née Hamm), great-grandson Robert Laudenslager, and granddaughter Annie Laudenslager (née Balliet).

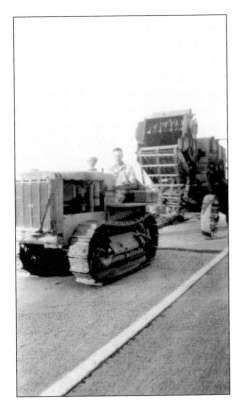

Driving along the cement pike (between Lynnville and Werleys Corner) Luther Laudenslager uses a 1938 Caterpillar 22 Crawler to move a threshing machine. Threshing machines were used before combines to separate the grain from the stalk. The straw was used as animal bedding.

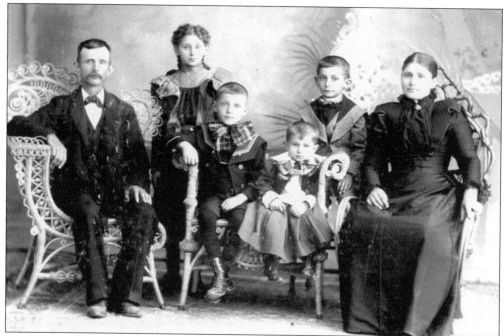

At the beginning of the 19th century, the Baush family traveled about 20 miles by horse and carriage to Lenhart's Ground Floor Studio in Allentown to have this photograph taken by a professional photographer. The family members from left to right are John David Baush (1863–1942), Kate R. Baush (1888–1964), Henry David Baush (1891–1969), Mark Adolph Baush (1897–1949), John William Baush (1890–1932), and Louisa Baush (née Mosser) (1865–1905). The family lived on a farm in Weisenberg.

The old orchard became a poultry yard for Milton and Sadie Zimmerman's purebred chickens at their Werleys Corner Hotel property. The Zimmerman's sold their fertile eggs to Price's Hatchery, Telford, from their accredited flock. Here in 1942, Donald Breininger models his Easter finery as the New Hampshire Red chickens can be seen in the background. After the hens passed their laying prime they were sold at the Fogelsville Live Poultry Auction.

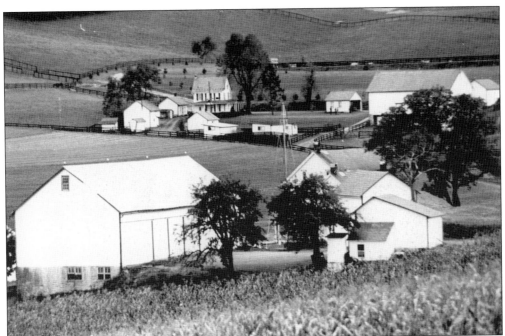

This scenic view of two beautifully maintained farms is located along Holbens Valley Road (the cement pike) just east of Werleys Corner. Two farms were created by the Seiberling family when they divided their original tract of land. Between the 1920s and the 1960s, the farm in the background was owned by Nathaniel and Addie Werley and the farm in the foreground was owned by Clayton and Lillie Rex. Unfortunately, the Rex barn was destroyed by fire.

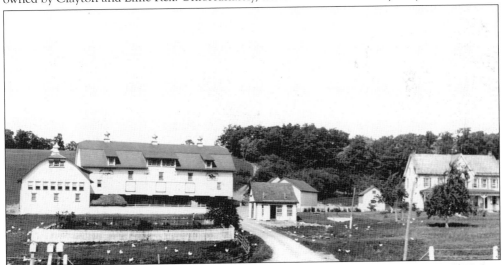

The Balliet/Laudenslager farm is located along Holbens Valley Road just west of Werleys Corner. It was purchased in 1847 by Stephen Balliet and remained in the family until 2002. Subsequent owners included William Balliet and Louisa Balliet (née Fenstermacher), George Balliet and Minnie Balliet (née Hamm), Luther Laudenslager and Annie Laudenslager (née Balliet), and Forrest Laudenslager and Nancy Laudenslager (née Weida). The home was built in 1898, replacing an older home on the property. Later a garage and chicken houses were added. Today the farm is an operating dairy farm.

Butchering animals was a common winter chore where neighbors, family, and friends gathered to assist. Here George Snyder of Pleasant Corner takes a break from practicing his butchering skills on the Clayton and Lillie Rex farm near Werleys Corner. The handy wheelbarrow is loaded with kindling wood used in butchering.

George Holben is pictured holding the reins of his horses on his farm along Holbens Valley Road. Horses were very important to farm life, and farmers took excellent care of them. A good farm horse lived approximately 25 years and was used singly and in teams. Some farming tasks where a single horse was used were pulling a plow, cultivator, or potato digger. Pulling heavier loads such as wagons loaded with potatoes, grains, or hay often required two animals.

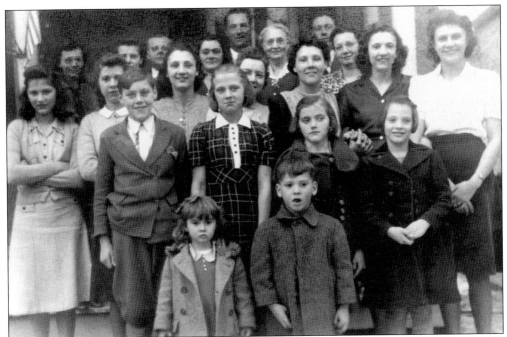

The Katie Holben family gathers for a family photograph at the home of Helen Loy in New Tripoli. The family from left to right includes (first row) Shirley Holben and Neil Kressley; (second row) Allen Holben, Eleanor Holben, Roma Holben, and Elaine Kressley; (third row) Annabelle Holben, Carolyn Holben, Edna Holben, Pauline Bittner, Wilma Kressley, Beatrice Holben, and Geraldine Loy; (fourth row) Perma Holben, Mildred Peter, Arthur Peter, Lillian Holben, Willard Holben, Katie Holben, Leo Kressley, and Helen Loy.

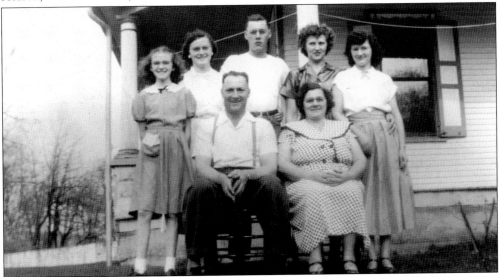

Gathering in this 1940s photograph during a family picnic are, standing from left to right, Shirley Wessner (née Holben), Roma Loch (née Holben), Allen Holben, Eleanor Snyder (née Holben), and Annabelle Merkle (née Holben). Seated are parents Willard and Lillian Holben at their home along Holbens Valley Road. The farm was in the Holben family for over 200 years. The house in the background was built by George and Katie Holben around 1915.

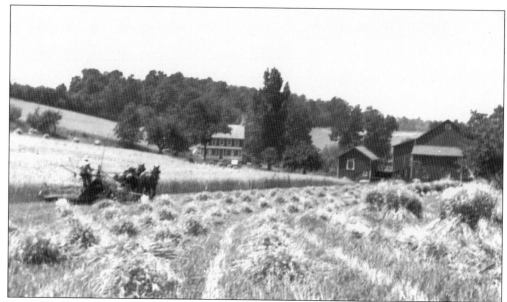

Daisy Baush (née Heintzelman) (1892–1968) owned and operated a family farm in Weisenberg Township on Ross Valley Road in the 1930s when this picture was taken. Daisy Baush, the widow of John William Baush (1890–1932), worked very hard to make a living during the depression. In this picture her son Clair Baush and her daughter Marie Fritzinger (née Baush) were harvesting wheat with a three-horse-drawn binder. After the binder cut the wheat it was raked by hand into shocks, which can be seen in the harvested portion of the field.

Clair Baush (1921–1997) was 15 years old when this picture was taken in 1936. Baush trapped muskrats, skunks, raccoons, and an occasional weasel in and around his mother's Weisenberg family farm. Muskrats and raccoons were caught in traps set along the creek. Baush caught skunks alive, and he had a way of catching them and never getting sprayed. He kept the skunks in several pens in the barn. Eventually the skunks were shot, skinned, and sold. Weekly a merchant came to buy the skins. Arlene Rauscher (née Baush), Clair's sister, remembers the merchant paid a higher price for skunks with blacker fur.

Farmers took pride in maintaining a neat farmstead such as this. George Ross and Emma Ross (née Bittner) owned this beautiful farm in the Bachman Valley near Sweitzer. George was a school teacher at the Weisenberg Church one-room school and superintendent of the church Sunday school for many years. George's sister, Emma, lived with the couple and helped with the farmwork. Since both women in the household were named Emma, George's sister was commonly known as *die gross* Emma, big Emma, while Mrs. Ross was referred to as *die glee* Emma, little Emma.

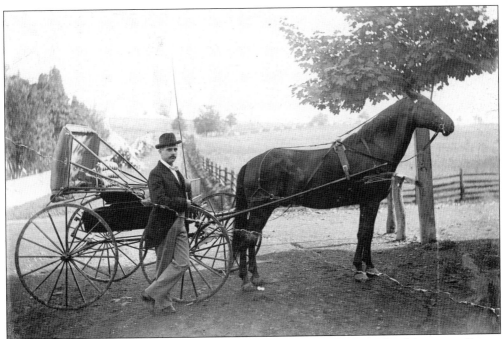

George Ross is shown with his horse and buggy, dressed in the dapper style of the times. George was known to call his horse by the name of Scott.

Ludwig Friedrich Rauscher (1913–2005) immigrated to Pennsylvania from Aich, Wurttenburg, Germany, in February 1930 at the age of 16, searching for better life. After brief employment in an Allentown silk mill, he was taken on as a hired farm hand by Clint and Agnes Eddinger (brother and sister) and later Elvin Bachman and Amanda Bachman (née Mosser). In 1936, Rauscher married Arlene Baush, a local farm girl, and together they bought the 45-acre George Ross farm on Ross Valley Road in Weisenberg Township. This photograph of Rauscher, taken in May 1939, shows him with lunch kettle in hand and foot on the running board of their 1931 Ford Roadster, ready to leave for his night job at the U.S. Steel Wire Mill in Allentown.

George Henry Reinert (1907–1991) and Luella Arlene Reinert (née Snyder) (1913–1995) owned and operated a 94-acre family farm on Ross Valley Road in Weisenberg Township. The Reinerts had a large truck farm in which they raised vegetables for a market route. The route was located in old neighborhoods in Allentown, Bethlehem, and Fountain Hill. Every Wednesday George and Luella loaded their red flatbed truck with vegetables and eggs and drove to town to sell their produce. Generally they stopped at repeat customers along the route. Their original market route was established in the 1930s by Luella's parents, Wilson Snyder and Katie Snyder (née Heintzelman). George and Luella can be seen dressed for market with change pocketbooks over their shoulders and oak basket in hand.

The dam on the Sweitzer Creek located along Werleys Corner Road on the Ralph Bittner farm was used for ice-skating and cutting ice blocks during the winter months. When the ice was about 18 inches thick it was cut into blocks and stored in an icehouse. The layers of ice were packed in sawdust and could be used through the summer in the kitchen's icebox. The dam is still there, but the barn burned in 1978 and has been replaced.

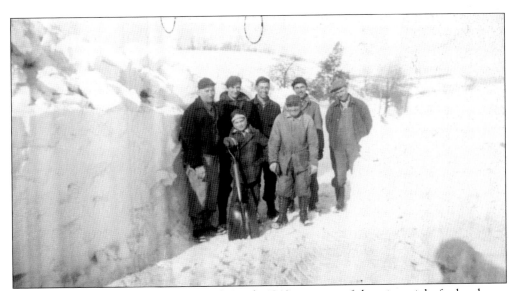

Hand shoveling through snowdrifts in the early 1940s was one of the winter jobs for local men and boys. From left to right are (first row) Arlan Bittner and Tom Brunner; (second row) Claude Bittner, Ralph Bittner, James Hunsicker, Peter Snyder, and Herman Kerschner. The drift is on Werleys Corner Road in Sweitzer.

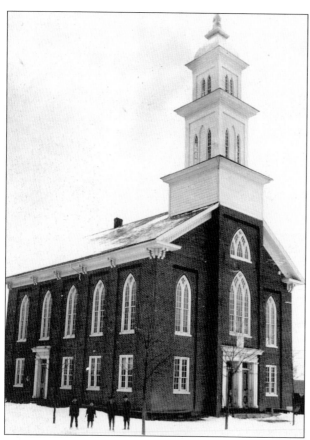

Weisenberg Union Church was founded in 1749 and its first log church was built in 1754. A second log church was built in 1803, which in turn was replaced by a stone structure in 1834. The fourth church, shown here, was erected in 1864. The bricks for the church were made in the Shoemaker Valley, east of the Lowhill Church.

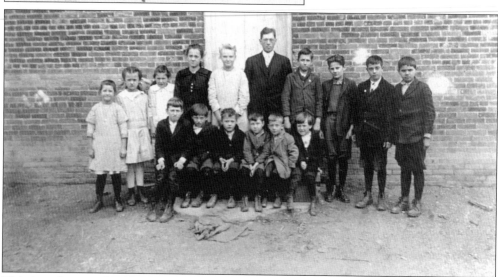

This is a photograph of Weisenberg Church School taken between 1919 and 1920. From left to right are (first row) George Reinert, Leo Kressley, Willard Holben, Herman Bieber, Russell Bittner, and Ralph Kressley; (second row) Ruth Bieber, Mabel Kressley, Lila Bittner, Malara Holben, Esther Holben, William Bieber (teacher), Ralph Bittner, Ralph George, Charles Bittner, and Harry Smith.

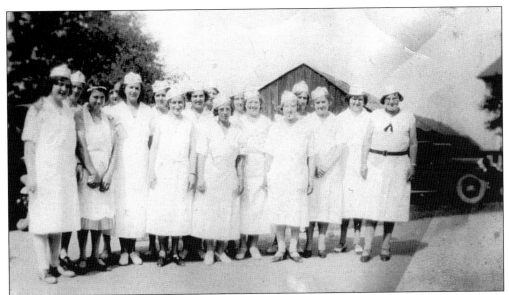

Family-style meals were served after Homecoming Services at Weisenberg Church in the 1930s. This was a fund-raiser to help the church's 1927–1928 renovation program. The waitresses pose in front of the old horse shed after getting their schedules. From left to right are Edna Kressley, Ella Miller, Lillian Snyder, Mabel Kressley, Mamie Hausman, Cora Hausman, Arlene Hausman, Roma Hunsicker, Perma Werley, Helen Snyder, Arlene Kressley, Lizzie Kemmerer, Marguerite Breininger, Mabel Brobst, Helen Kressley, Luella Snyder, and Lila Bittner.

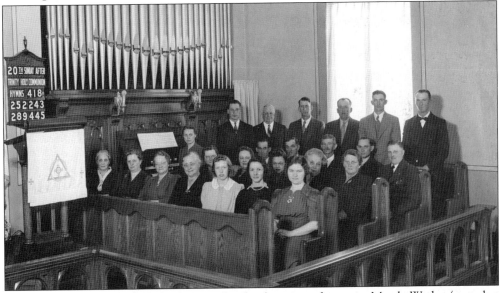

This is the Weisenberg Church choir, under the direction of organist Myrtle Werley (seated at the organ), at a Fall communion service in 1941. The members from left to right are (first row) Katie Holben, Estella Hahn, Mamie Kemmerer, Lizzie Sechler, Althea Kressley, Jennie Siebert, and Lillian Herber; (second row) Arlene Roth, Lizzie Kemmerer, Dorothea Holben, Ellie Bittner, and Addie Werley; (third row) Weldon Werley, George Seibert, William Sechler, Howard Hahn, and Harold Wiltrout; (fourth row) Raymond Kressley, Robert Kemmerer, L. James Werley, Arthur Kressley, Ralph Bittner, and Willard Holben.

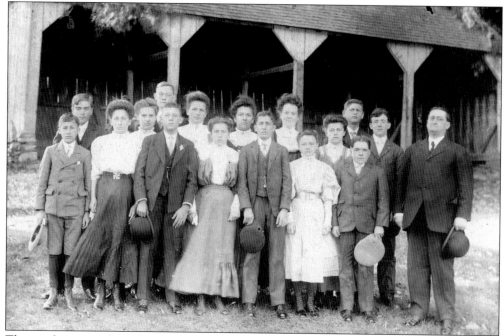

The confirmation class of 1909 pose in front of the horse sheds at Weisenberg Church. Rev. Elmer Leopold is on the right. Class members were Mabel, Paul, Pearl, and Astor Bittner; Clarence Hollenbach; Lillian and Verna Kressley; William Held; Ira Fisher; Beulah, Robert, and Ira Stump; Clara Werley; Marcus Hausman; and Lula Nonenmaker.

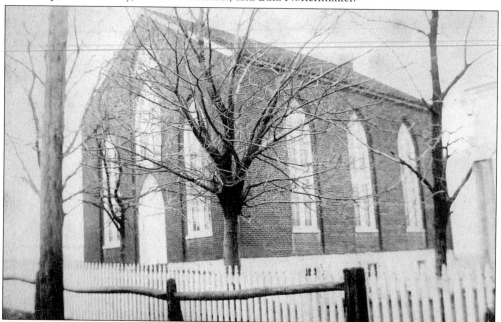

Located along Werleys Corner Road the Seiberlingsville Church has served both the United Church of Christ and the Lutheran congregations for many years. Today the white picket fence is gone, but the church still serves as a house of worship for the United Church of Christ congregation. The horse rail in the foreground was used to tie horses and carriages during services.

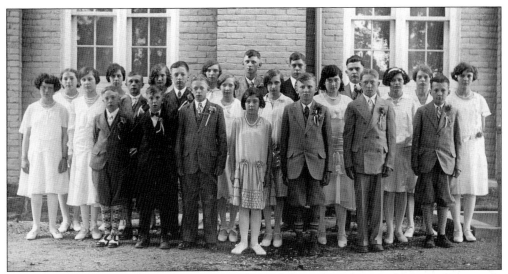

This 1930 photograph of the Weisenberg Township eighth-grade graduating class was taken outside Weisenberg Church. The graduates are Elwood Heiser, Frank Potsman, John Lutterschmidt, Lauretta Ruch (née Fister), Richard Bleiler, Clarence Hoffman, Ernest Bleiler, Helen Gehringer (née Acker) (post graduate), Margaret Krautsock (née Nicholas) (post graduate), Margaret Lowy (née Hartman), Martha Masters, Leroy Pfeiffer, Mildred Koch (née Bleiler), Kenneth Heffner, Minerva Hamm (née Held), Arlene Rauscher (née Baush), Ralph Ebert, Laila Arndt (née Danner), Elmer Kocher, Pauline Wagner (née Sechler), Kenneth Zimmerman, ? Schmeidel, May Zimmerman (née Kerschner), and Mary Alice Risser (née Christman).

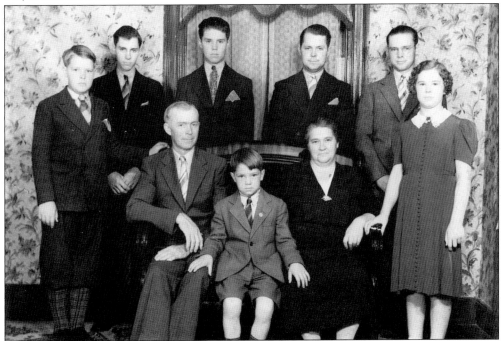

Dressed in their Sunday clothes, the Loch family poses in their living room for a family picture at their home along Loch Valley Road. From left to right are (first row) Warren, Kermit, and Mabel Loch; (second row) Mervin, Allen, Elmer, Carl, Willard, and Mildred Loch.

113

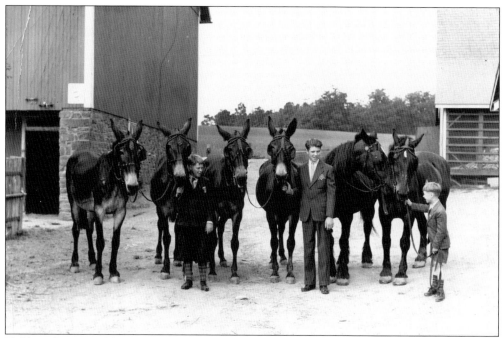

Holding the reins of four mules and two horses are Mervin, Elmer, and Kermit Loch. The animals were used on Warren Loch's farm. They were brought out of the barn to be seen by the Sunday afternoon visitors.

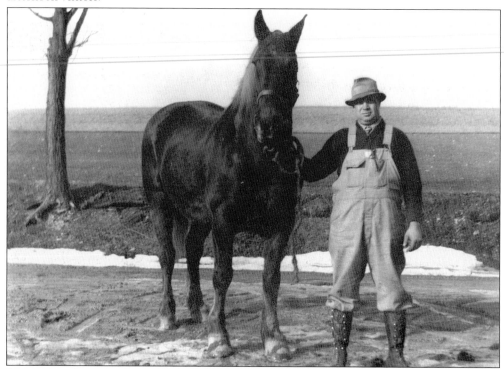

Pictured on the Carpet Road farm of George Balliet and Minnie Balliet (née Hamm) is Edgar Wehr in his high work boots and coveralls. Wehr is ready to do fieldwork.

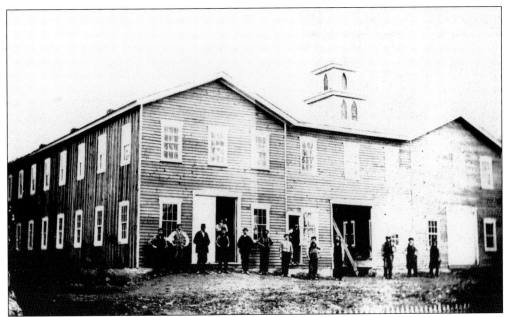

An early community industry was the Sechler Wagon Works in Seipstown. Operating for about 45 years, beginning in 1876 under the name of Sechler and Brothers Carriage Works, the firm manufactured carriages, box wagons, buggies, sleighs, spring wagons, and hearses. The Sechlers also made grain cradles (several examples still can be found in the area). The business was first started by Peter Seip in 1870.

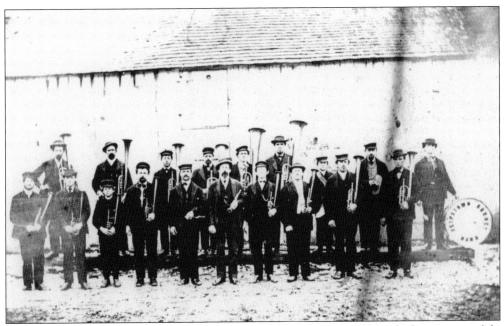

Music was an important part of resident's personal development and enriched community life. Most sizable villages formed a band that performed at picnics, political rallies, and local events. In this 1890s photograph are members of the Seipstown Cornet Band posing in front of the livery stable before an engagement.

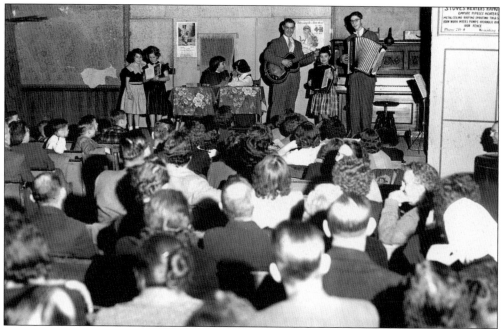

The Seipstown Literary Society was a social and community organization dedicated to community growth and culture in Weisenberg Township. It was organized by Roland L. Rupp, a Muhlenberg College graduate, on April 9, 1915. The society met monthly in the former Zion United Brethren Church in Seipstown. The society bought the building for $4. During its long existence many musical programs, plays, dialogues, debates, minstrel shows, picnics, parades, and parties were sponsored. These are photographs taken at a musical in 1952. The last meeting was held on April 11, 1970, and the building was donated to the township.

"The Jones Boys," a minstrel show, was presented by the Seipstown Literary Society in 1953. From left to right are (first row) Sterling Zimmerman, Charles Kistler, Royden Dotterer, Kenneth Zimmerman, Forrest Fetherolf, Larry Dotterer, Ralph Zettelmoyer, Robert Laudenslager, and Ralph Bittner; (second row) Leola Werley, Kathryn Heiser, Myrtle Barto, Ralph Gruber, Althea Kressley, Melville Lackey, Marilyn Moyer, George Rupp, Lillian Dotterer, Addie Schroeder, Russell Bittner, Barbara Werley, Samuel Barto, Louise Werley, Nancy Moyer, Raymond Kressley, Helen Lackey, Marion Bittner, and Lillian Kressley.

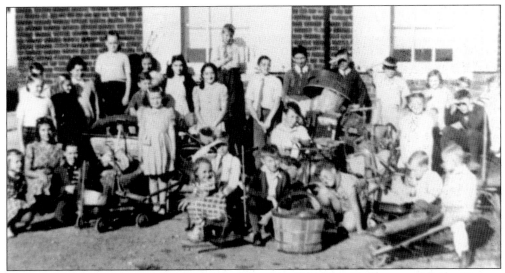

This scrap metal drive was held at Seipstown School in 1944. Identified here are Marilyn Durner (née Miller), Richard Smale, Dick Baker, Edwin Snyder, Carl Breininger (with wheel barrow, he did not attend school yet), Gloria Hausman (née Hoffman), Lois Gangaway, Edward Wagner, Beulah Snyder (née Burkhardt), Eldred Snyder, Robert Baker, Clara Hahn (née Sechler), Carl Baush, Lois Bittner (née Wagner), Marilyn Beitler (née Haas), Dennis Heiser, Marian Scheirer (née Bittner), Charlotte Schumaker (née Gregory), Fern Grammes, Betty Billig (née Wagner), Roberta McMillan, Betty Haas, Wilbur Gangaway, Richard Bittner, Henry Haas, Loftin Gregory, Sherwood Haas, Virginia Schiffer (née Smale), Carl Haas, Elaine Breininger, and Gerald Breininger.

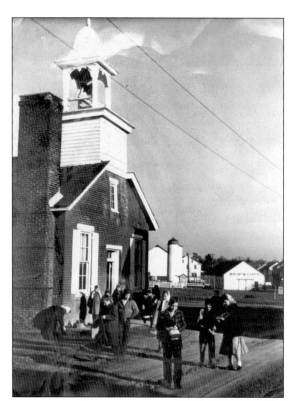

Students are seen leaving Seipstown School for home in 1949–1950.

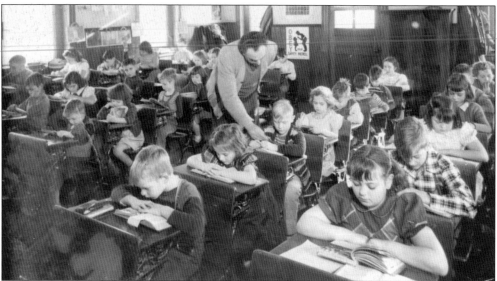

Here are the students of the Seipstown School in 1949–1950. Identified here are Edwin Snyder, Gloria Hausman (née Hoffman), Ronald Werley, Clara Hahn (née Sechler), Chester Haas., Gary Flyte, Shirley Wagner, William Harrich (hand raised), Marie Hertzog, Janice Haas, James Hertzog, Barbara Carl, Jay Flyte, Evelyn Wagner, Carl Breininger, Alfred Haas, Lorraine Sheetz, Carl Hoffman, Barbara Geiger, Ray Peters, Gene Flyte, Bruce Snyder, Mary Henry (née Bittner), Janice Sechler, Larry Sheetz, Janice Wagner, Janet Bender (née Krause), Garian Carl Jr., and Janet McCauley (née Shade). The teacher is Charles Heiser.

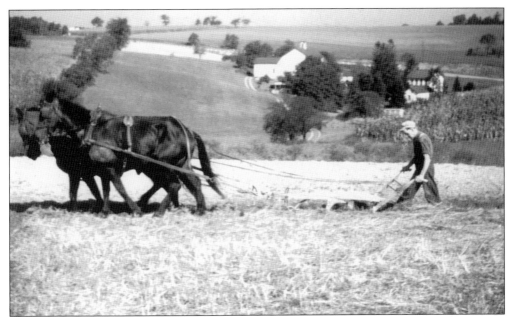

Clarence W. Rupp (1889–1957) is plowing with horses on his west side farm near Ziegels Church on September 3, 1947. His son the Reverend William J. Rupp (1911–1966) snapped this photograph. The horses were named Dick and Harry. Clarence farmed his entire life with horses and never owned a tractor. In his later years, he sometimes hired local farmers with modern farm equipment to help with harvesting.

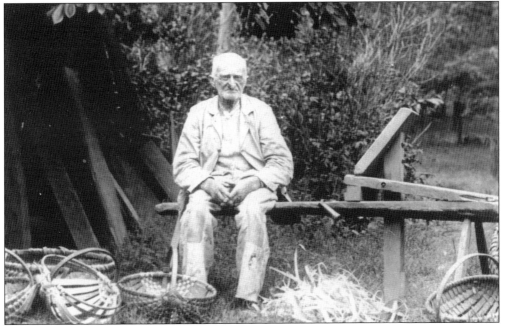

Baskets were an important part of everyday farming operations and used for many purposes including picking potatoes, gathering eggs, and collecting nuts. John Brunner sits on his *schnitzelbank*, or "carving bench," near Ziegels Church around 1920 where he both repaired and wove new baskets from strips of oak.

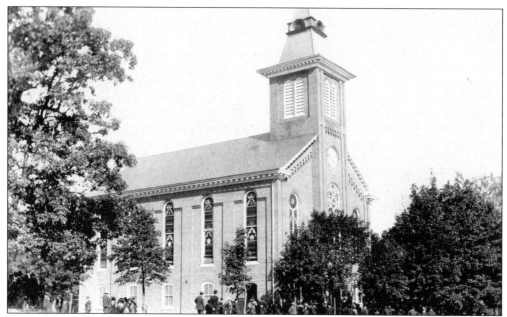

Here is the fifth and present Ziegels Church, built in 1908. After lightning destroyed the third church, the congregations dedicated another brick church in 1889. The Boyertown Mutual Fire Insurance Company reluctantly insured the building, noting that nearly every church it had insured with a spire had been struck by lightning. A lightning bolt caused the fourth church to burn in 1907. The fifth church, built within the existing walls at a cost of $16,491.34, had a notably shorter steeple. A rear addition in 1956 and a new wing in 1990 were added. Ziegels still remains home to two congregations, the United Church of Christ and the Evangelical Lutheran Church in America, one of about 40 union churches.

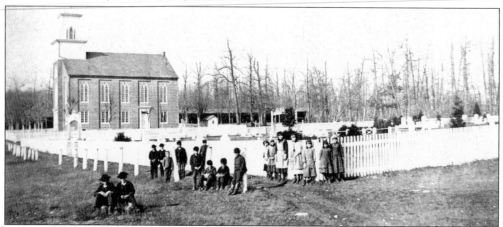

Here is Ziegels Church's (1863–1887) third building. Formed before 1750, Ziegels Church established a union agreement on July 29, 1750, in which two denominations would share the facility. The first church was a log cabin, replaced by a stone church in 1796. When the congregations outgrew this space, the stone church made way for this $7,000 brick edifice, erected in 1863. Horse sheds and the outhouse are visible behind the church. In 1874, the cemetery was enclosed with a picket fence; the posts outside allowed mourners to tie their horses. The wonderfully tall steeple attracted a "shaft of electric fluid" on July 6, 1887, causing the destruction of the church.

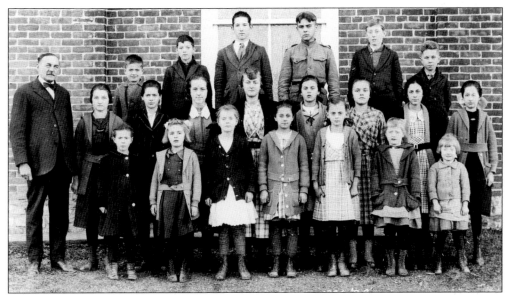

In 1750, the Ziegels congregation made provisions for a schoolhouse and burying ground. The first school was a log structure; by 1796, the congregations replaced it with a stone structure. The church operated the school until 1893, when it rented the facility to Weisenberg Township for a public school. Here is a photograph of Victor Ziegler's (far left) 1921–1922 school class. From left to right are (first row) Martha Masters, Goldie Heffner, Elsie Masters, Olive George, Nettie Ziegler, Ruth Walbert, and Carolyn Walbert; (second row) Margaret Smith, Mary Masters, Perma Kistler, Erazoola Kistler, Hallie Ziegler, Lulu Bleiler, Luella George, and Helen Sechler; (third row) Paul Masters, Charles Moyer, Paul Moyer, Theodore Bleiler, Harold Walbert, and William Rupp.

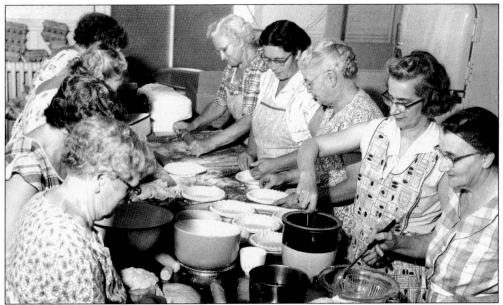

In the 1940s, photographed are members of the Ziegels Ladies Aide Society who are baking apple pies for a fund-raising event. On the left side, front to back, are Edna Folck, Alverta Mengel, Myrtle Barto, and Helen Lackey. On the right are Verdie Fister, Limmian Fritz, Katie Snyder, Lillian Werley, and Ida Bailey.

Here is a photograph of the Fritz homestead taken in 1950, before new Route 22 (now Interstate 78) was built. The homestead is on the west side of New Smithville. It was originally owned by Charles Fritz, Osville J. Fritz's father. He was an undertaker, farmer, and sawmill owner. Charles also made cider and vinegar on the property. The undertaker's facility was located in the front of the house. The barn and shed were torn down in 1957 for the new highway. The barn had a history of being hit by tractor trailers traveling on old Route 22. The barn was hit seven times, once by a truck carrying dynamite.

Osville J. Fritz owned an automobile repair shop along old Route 22. In 1930, Fritz received a franchise for Ford and built a new building across the highway from the small repair shop. The dealership was run by his children Paul and Lillian. During World War II Fritz added a Ford tractor and farm implement franchise. In 1980, the Fritzs received a 50-year service plaque from the Ford Motor Company. Although Fritz continued to sell used vehicles, repairs and service were the primary business until the garage was sold at auction in October 1999.

Standing behind their bar of the New Smithville Hotel, Henry and Mildred Acker (née Ritter) pose with their extensive collection of brass bells, buckets, and lanterns. The Ackers operated the general store next to the bar room as well as serving delicious food and drink. An Old Dutch Beer clock keeps the time of day.

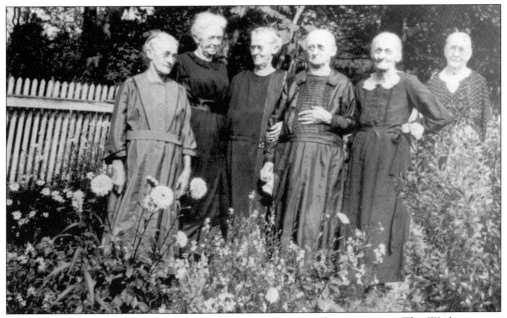

Examining fields and gardens was a part of every Sunday afternoon visit. The Werley sisters, daughters of Michael Werley and Catherine Werley (née Mosser), gather around 1925 at the Holbens Valley home of Emmalina and Sarah to inspect the garden. From left to right are Anna Oswald, Emmalina Werley, Katie Hollenbach, Caroline Weiss, Sarah Oswald, and Mary Weida. The beautiful blooms met with everyone's approval.

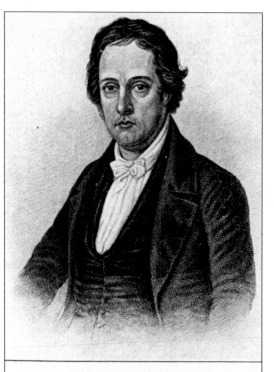

Johannes Helffrich.

The third son of Johann Henrich Helffrich and Mary Magdalene Helffrich (née Sassamanhausen), Johannes (1795–1852) decided at age 12 to pursue the ministry. After his father's death, he studied under Rev. Samuel Helffenstein in Philadelphia for five years. While a student in Philadelphia, he received a call to minister in Heidelberg, Lynntown, Lowhill, Weisenberg, Ziegel, and Long Swamp. It was a charge he served until his death. Johannes conscientiously wrote his sermons and typically delivered them in less than half an hour; he possessed a fine musical voice. His other passion was homeopathic medicine. On April 19, 1818, he wed Salome Schantz. They had two sons, Dr. John Heinrich Helffrich, a homeopathic physician, and Rev. William Augustus Helffrich, a German Reformed minister.

William Helffrich (1827–1894) attended the parochial school at Ziegels Church. Then privately tutored, Helffrich completed his studies in 1845. Before his 18th birthday, he was ordained a minister. Typhoid fever forced him to resign his charges in Reading and Reverend Helffrich spent time out west to improve his health. From 1848 to 1852, he helped his aged father and upon his father's death, he assumed his father's charge. Described as "a gifted pulpit orator," Helffrich preached twice each Sunday. His autobiography, *Lebensbild*, published posthumously in 1906, provides a revealing view of his life and times. On August 1, 1852, he married Amanda H. Fogel, daughter of Solomon Fogel Esq. Their four sons were Dr. John Helffrich and Dr. Calvin Helffrich, homeopathic physicians in Fogelsville, and Rev. Nevin W. A. Helffrich and Rev. William Ursinus Helffrich.

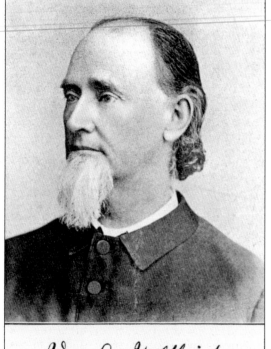

Wm. A. Helffrich.

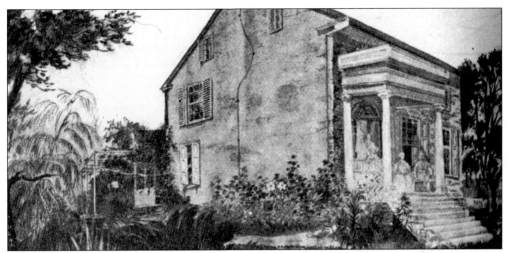

Located on old Indian Road in Weisenberg Township, now Kistler Court, this 1830 home has stood vacant for two decades and now is threatened by industrial development. In its formal parlor, Johannes Helffrich performed baptism and wedding ceremonies for many a community resident. Helffrich allowed stonecutters, carpenters, smiths, and even a chocolate manufactory (run by his brother Daniel) to conduct business on the premises. He brought schoolmasters from Germany for the education of his children and others. From 1834 to 1840, the curriculum of the Helffrich or Weisenberg Academy consisted of German, Latin, Greek, natural philosophy, geography, ancient and biblical history, physiology, religious instruction, and letter writing for composition. The home also served as the Helffrich Hospital; patients called at the home for treatment from Helffrich or his associates. Helffrich's medical kits, used at this residence, now are part of the collection of the Smithsonian Institution.

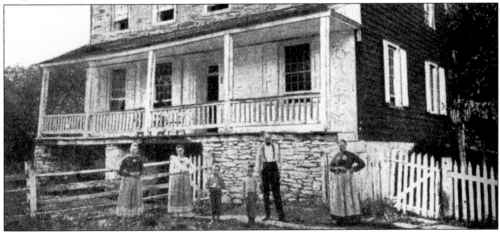

Considered the father of the German Reformed Church in America, Johann Henrich Helffrich (1739–1810) studied theology at the University of Heidelberg. In 1771, he and his half-brother Johann Albert Conrad Helffenstein came as missionaries to Pennsylvania. He built this home, now located on Snyder Road in Weisenberg Township, as his base of operations for the many parishes he served in western Lehigh and eastern Berks Counties. To fulfill the duties, he traveled extensively on horseback, his meerschaum pipe his constant companion. He suffered a fatal stroke while mounting his horse on an errand of mercy. Four generations of his descendants served the German Reformed Church; many are buried at the cemetery of Ziegels Union Church, where a special monument stands in honor of the family.

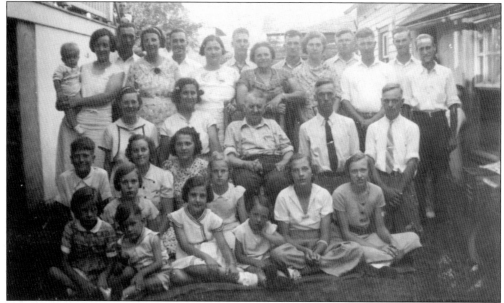

Family gatherings were days filled with food, games, and merriment. Frank Kressley is surrounded by his grandchildren and great-grandchildren at the home of Elmer and Ida Kressley in 1938. Here from left to right are (first row) Fern Kistler and Willard Kressley; (second row) Lillian Kressley, Jean Kressley, Elaine Kressley, Naomi Kressley, and Althea Kressley; (third row) Carl Kistler, Verna Fries, Evelyn Kressley, and Pauline Fries; (fourth row) Estella Kressley, Margaret Kistler, Frank Kressley, Charles Fries, and Kenneth Fries; (fifth row) Mabel Bittner holding her son Donald Bittner, Perma Werley, Edna Kressley, Bessie Haas, Arlene Kressley, Russell Kressley, and Marvin Fries; (sixth row) Leo Kressley, Ralph Kressley, Raymond Kressley, Clyde Kressley, Paul Breininger, and Ernest Fries.

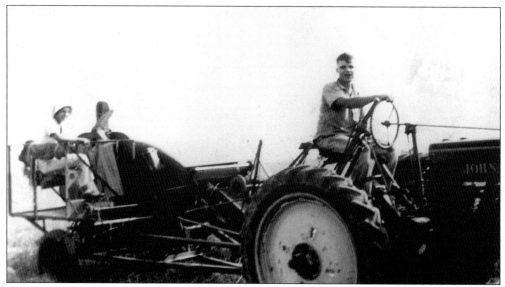

Grain harvesters changed greatly over the years. Angus and Marie George proudly display the capabilities of their new grain combine in 1942. This was the first combine in Weisenberg Township.

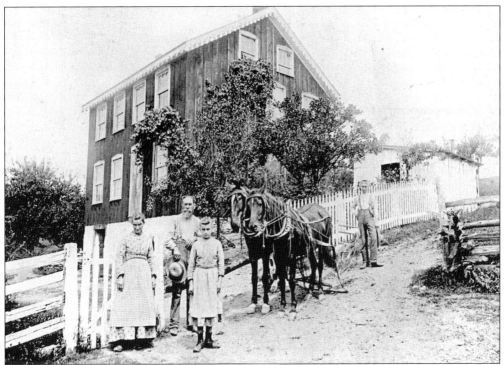

The Benjamin Bittner family farmed the first farm west of Weisenberg Church for four generations. Joel Bittner and his wife Messina Bittner (née Fink) are shown with their daughter Emma and son Albert. They also included their team of horses in the photograph—a farmer's most valuable possession.

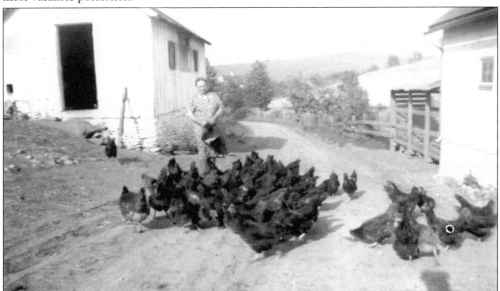

Oyer geld, egg money, was a very important source of income for the farm wife as it produced that extra cash needed for household supplies and necessities. Tevillia Snyder of Lyon Valley continued the farming operation of her parents Milton and Sarah Werley. In this photograph Snyder is carefully tending her poultry flock as she feeds them in the middle of the public road.

ACROSS AMERICA, PEOPLE ARE DISCOVERING SOMETHING WONDERFUL. *THEIR HERITAGE.*

Arcadia Publishing is the leading local history publisher in the United States. With more than 3,000 titles in print and hundreds of new titles released every year, Arcadia has extensive specialized experience chronicling the history of communities and celebrating America's hidden stories, bringing to life the people, places, and events from the past. To discover the history of other communities across the nation, please visit:

www.arcadiapublishing.com

Customized search tools allow you to find regional history books about the town where you grew up, the cities where your friends and family live, the town where your parents met, or even that retirement spot you've been dreaming about.

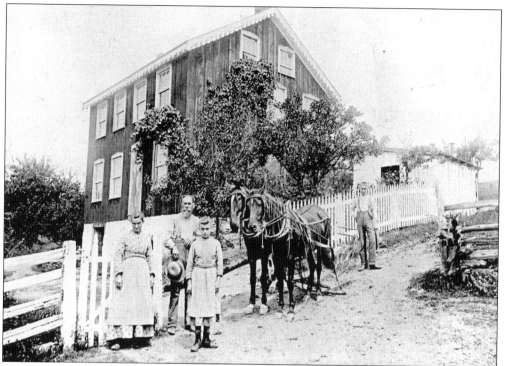

The Benjamin Bittner family farmed the first farm west of Weisenberg Church for four generations. Joel Bittner and his wife Messina Bittner (née Fink) are shown with their daughter Emma and son Albert. They also included their team of horses in the photograph—a farmer's most valuable possession.

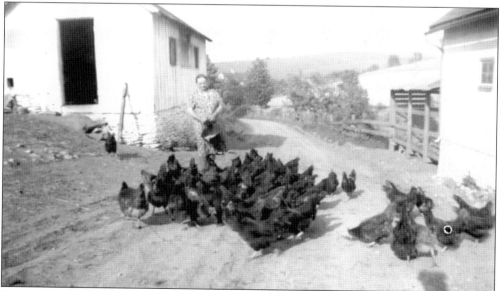

Oyer geld, egg money, was a very important source of income for the farm wife as it produced that extra cash needed for household supplies and necessities. Tevillia Snyder of Lyon Valley continued the farming operation of her parents Milton and Sarah Werley. In this photograph Snyder is carefully tending her poultry flock as she feeds them in the middle of the public road.

ACROSS AMERICA, PEOPLE ARE DISCOVERING SOMETHING WONDERFUL. THEIR HERITAGE.

Arcadia Publishing is the leading local history publisher in the United States. With more than 3,000 titles in print and hundreds of new titles released every year, Arcadia has extensive specialized experience chronicling the history of communities and celebrating America's hidden stories, bringing to life the people, places, and events from the past. To discover the history of other communities across the nation, please visit:

www.arcadiapublishing.com

Customized search tools allow you to find regional history books about the town where you grew up, the cities where your friends and family live, the town where your parents met, or even that retirement spot you've been dreaming about.